Fix Your Face
and
Watch Your Tone

Women Know What's Needed

Your Tone Is
Always Right

love you '75.

ALWAYS RIGHT

Fix Your Face
and
Watch Your Tone

Women Know What's Needed

A Guide to Having It
All Without Doing It All

Dr. V Boykin

Strategic Book Publishing
www.sbpra.net

For information about special discounts for bulk purchases, please contact Strategic Book Publishing, Special Sales, at bookorder@sbpra.net.

ISBN: 978-1-63410-212-4

Dedication

This book is dedicated to the tribe of women (and allies)
who continue. We know our struggle, and we continue.
We understand the challenges, and we continue.
We recognize the perils, and we continue.
Please know you are seen, and please continue.

Table of Contents

Acknowledgements

One of my most closely held beliefs is, "*The universe is conspiring in my favor.*" Many times, when situations get tough, it has not felt that way. During those times, my daughter reminds me, "Mom, it is the middle, and the middle always feels this way. You can't see the end or the beginning, but you have already made it to the middle." I would like to acknowledge my daughter, Vanessa, and her wise counsel.

My appreciation for the men in my life is boundless. My son, Justen, has a resilience and tenacity that is unmatched. Thank you for choosing to spend your time in the presence of strong women and valuing their thoughts, ideas, and opinions. I am so proud of who you are as a person. The world is full of more wonder and kindness because of your presence. My grandfather, Sam, whose investment and support continues to impact the present even in his absence.

As I stress in this book the importance of selecting or creating the 'right partner,' I acknowledge my husband, Mark. He is my biggest cheerleader and voices such solid belief in my abilities, I am forced to expand my dreams. Thank you for holding space for my point of view, supporting and amplifying my voice, providing a ferocious defense of my right to define my existence, and the most gentle place to land when the ground beneath me becomes

unsteady. Married is a status; being happily married is a choice. I am so glad to be happily married to you.

Perhaps the most impactful examples in my life are the women in my family: my grandmother, Barbara, whose influence and love are felt daily, even in her absence. My mother, Diane, whose sharp wit and skillful writing is the best inheritance I could ask for. And my Aunt Jan and Aunt Norma whose unwavering support has propelled me forward even in the darkest of times. Growing up amid their strength and power made it impossible to resist being swallowed and then floating on waves of possibility. Lastly, Maddie, who is and will continue to be one of the brightest and talented young women I know.

I also acknowledge my inner circle that always shows up to support me: Anita Mazkoori, Dan Tyre, Michele Brady, Sacha Dekker, Tanya White, and my BGM Tea Time group. Thank you to my yoga community, who reminds me of what I already know and encourages me to breathe into the uncomfortable spaces. Within this group falls my dissertation Chair, Dr. Syleecia Thompson, who encouraged me and concretely modeled for me the "what can be" and "what should be." I have tremendous respect for your intellect, advocacy, and empathy.

I thank my professional circle that reaches back as they push forward: Aaron Jones, Al Smith, Alan Stein and his work at Kadima Careers, Arlan Hamilton, Jeetu Mahtani, Dr. John C. Turner and The Doc Chat Group, Mandy Thompson, and Sara Dean. Thank you to my extended family and friends, who have grounded and encouraged me over the years.

I would like to express my appreciation to my marketing team, Oliveira and Company, which took a chance on me and delivered an incredibly cohesive brand that showcases the real me. A special thanks to Brad Reed (bradreedphotography.com), who captured my soul and then made it glossy. Thank you.

To the allies who see us and ensure others acknowledge our brilliance and contributions, you have my most profound appreciation. I know the road can be lonely and isolating. The space you create for true belonging makes a difference, and I see you and your efforts.

To the courageous women who anonymously participated in my study–you are always with me. To all Readers, remember, you are always exactly where you are supposed to be, at the time you are supposed to be. *The universe is conspiring in your favor.*

Introduction

You've Got to Be Kidding

In her song "Don't Start Now," Dua Lipa asks if heartbreak has changed her. Her response, "Maybe," rings true. My breakups have changed me, but they don't get credit for how I moved on. My former relationships are a footnote to the incredible strength I discovered when I rebounded from the hurt and fear of goodbye. They don't get credit for my realization that nothing–and no one–can stop me.

"How long are you going to be mad about this?" he demanded. I thought long and hard. Any other day, another episode of my ex-husband's cheating would have made me shrink, bend, and silence myself to safeguard my family's financial security. Any other day, I would have responded by frantically cleaning the house to create the appearance of a "perfect" life and to prove my worth. Any other day, I would have decided to stay–I always decided to stay.

That day, the moment he asked me how long I would be "mad" (understatement of the century), I knew I had to leave sooner rather than later. I had hit my threshold of insults, and putting a time constraint on my outrage was the final straw. But how would I balance it all? How would I manage my day-to-day life? How

would I feel safe, secure, and capable? I didn't even know where to start. I imagined introducing myself as a single woman without the protection of a wedding band. I imagined hitting the dating scene and finding the wrong type of partner...again. I imagined trying to figure it all out and feeling paralyzed.

Then came the glaring reminder that I didn't have the credentials to get ahead. I mean, I had a full-time job, but I wasn't earning much, nor was I confident enough to strike out on my own. With my felony record, I was always on edge, knowing that if I lost a job, I might not be able to find another one that paid enough to support my family.

"I'm not sure how long I'll be mad about you cheating yet *again*, but it's certainly going to take longer than the two days it's been since I found out," I replied. I was proud of my response, the strength in my voice, and the boldness in my tone. I was finally pushing back, and it felt good.

"Then I think we need a divorce," he responded, "because I don't want to deal with this."

I felt the blood drain from my face, and my boldness was quickly replaced with doubt. My mind still reeling, I demanded, "*You* created this mess, and now *you* don't want to deal with it? Why did we bother with marriage counseling? Why did we bother investing in the last ten years together?"

At the same time, a small part of me screamed out from the depths: *Freedom! You are going to have freedom!* It was a tiny flicker of hope hidden beneath overwhelming grief. More than anything, though, I was overcome with feelings of hopelessness and isolation. I realized I was falling into the same patterns I witnessed growing up–finding an unsupportive partner who inspires choices that benefit them while contradicting your own best interest. The result is a profound loneliness hidden behind the facade of a seemingly idyllic relationship, personal goals and ambitions be damned.

"I don't know, but I never wanted a wife that was this Black and this liberal." He had finally said the quiet part out loud, and everything clicked at that moment.

I recalled the conflict between us as I celebrated and supported PRIDE month all year long. I remember conflict when I told him I wanted to work in corporate DEI. I remember conflict when I told him I believed Dr. Christine Blasey over Brett Kavanaugh (because I had similar experiences, but never enough boldness to face my perpetrator), and even more disagreement when I asked him why we only ever had his white friends over. I remember conflict when I asked him why all the managers at his construction company were white while everyone doing manual labor was Brown. I remember conflicts when I told him to stop calling people who looked or loved differently "freaks." I remember his excuses, explanations, and fake apologies.

For a decade, I hadn't acknowledged any of these microaggressions in a way that created any change. Reflecting on my only romantic relationship with someone from the majority population, a white man, was painful. I realized how much space I had relinquished in the relationship, all the parts of myself I had silenced, and all the compromises I had made. I had supported this man at the expense of my own career, and I had no plan B. I wasn't even sure I ever had a plan A.

When I turned my attention to my experiences in the corporate landscape, I saw painful parallels. There were times I was silent, or just argued, but without the results of any concrete change, other than the demise of my professional reputation. I endured the 'othering' and being passed over for promotions or leadership roles because I was corporate America's version of "too Black and too liberal." I was victimized by invisible quotas implemented to prevent career advancement for more than "just one." I heard the comments when my presence as a Black woman in the room was missed due to the lightness of my skin, and the fake apologies without consequences once they "saw" me.

At times, I stayed silent, so I didn't lose my standing, damage my reputation, or get labeled and cast aside. After all, no one wants to work with the person who says, "Maybe we should promote qualified Black people to leadership to celebrate Black History Month instead of just hosting an informational session", "How is it possible that our senior leadership team only has one woman?", "Maybe we should re-examine our hiring practices given that we don't have any Black employees in sales leadership positions as a global company?", "Maybe we could be more inclusive of other religions so everyone can feel comfortable during the month of December?", and my personal favorite, "Why are all the images of people in the presentation deck cis, white, tall, thin men?"

As I navigated my way through divorce, I knew one thing: I needed to find a way to prevent my daughter and other women from repeating my mistakes. I wanted to create a guide for others that clearly identified the traps that lead to "bad" choices. I was (and still am) determined to help others avoid what I experienced over and over again by sharing what "better" choices look like. I wanted to show women that they can have it all without doing it all.

I wrote this book because I want women to have fantastic, fulfilling careers and peaceful, exuberant personal lives. My goal is to empower women to make decisions that improve their quality of life and to help them navigate a world that still judges women for their attitude over their accomplishments. I knew any advice I shared needed to be backed by science, not just by anecdotal evidence, so women could feel confident that my words were rooted in fact.

The following chapters combine extensive research with the lived experiences of working women, culminating in solutions for improving work-life balance and employee well-being. These secrets to success can be implemented by individuals or better yet, by companies for the benefit of their employees. Whether you are a company leader or a marginalized employee, the information in this book will change your life. It has certainly changed mine.

4

In the Beginning

This chapter brought to mind "Ladies First" by Queen Latifah. Throughout the song, Latifah dismantles the stereotype that women can't rap or "flow," skillfully adding a fresh, female perspective during an era of male-dominated rap. This book serves to accomplish a similar goal for the corporate landscape.

In 2020, when I began my doctoral research on women, equity, and leadership in the technology field, I came across an unexpected statistic: 80% of female leaders in the technology field said their spouse's support was what enabled them to obtain leadership positions.[1] As a feminist and a three-time divorcee, I needed to know how the support of a spouse (or spousal equivalent) could be the predominant factor in these women's achievements. There was no way a woman's professional success could be reduced to "having a husband" (talk about a cliche). So, I decided to dive deeper: What *exactly* was it about having a supportive partner that allowed the women from this study to reach such levels of success? What were their supportive significant others doing that allowed the women to excel in their leadership roles? The underlying theme: exceptional social support.

I knew I couldn't possibly tell other women, or myself, for that matter, that they needed a spouse to reach new heights in their

careers. After all, it's not like people have "incredible social support" listed in their dating profiles. I've done my fair share of online dating, and I know it's just not that easy. I began to ponder what it meant to be a so-called "perfect spouse." Was there a way for women to *create* the perfect spouse to support their career advancement? This question became the focus of my doctoral research. My study identified key areas that support women, and those who identify as women, in advancing their careers while achieving and preserving work-life balance. Sound too good to be true? It's not. We'll examine those fundamental support areas and how they address inequity in the workplace.

As a woman (men and those who identify as male—stay tuned for the chapter on allyship and other essential literature), at some point in your life, you probably experienced a relationship that negatively impacted your personal and professional life. You may even be involved in that relationship right now. The lack of support you experienced may have left you feeling angry, confused, and frustrated, among other emotions. You may have been shut down or shut out. You may have made difficult choices and sacrifices for the sake of the relationship that changed the trajectory of your life and career. Does this sound familiar? Don't worry, you are not alone. In fact, these feelings are so common they are backed by science.

Let's set the stage for life as a woman. Research has shown that women will have a more challenging time making it through school for many reasons, including gender bias,[2] relationship roles (the not-so-supportive partner), traditionally assigned domestic responsibilities (dishes, laundry, cooking, cleaning—the works), micro- and macro-aggressions in the workplace,[3] and unequal parenting responsibilities, to name a few. Despite these challenges, 46% of women graduate college, compared to 36% of men.[4] This creates a well-educated, diverse workforce of women ready for lucrative, full-time employment, yet the landscape remains monolithically white and male; what gives, hiring managers?

Enter stage left: employment discrimination. That's right, there is a significant disparity in hiring statistics. As a woman, it is quantifiably more challenging to be hired, let alone to be promoted to a leadership role. Further evidence shows women face disproportionately more obstacles in the workplace than men, including gender discrimination, stereotyping, tokenism, sexual harassment, and a demoralizing work environment.[5] Yes, the odds are stacked against you in the workplace (and in many other areas, but there's plenty of other literature covering that already). To state the obvious, you deserve all the social support and equitable advantages you can get (much more about that later).

Women are also severely underrepresented in leadership positions, meaning a potential for more hiring bias and fewer BIPOC employees, among other workplace injustices. Fewer technology startups have women as founders, in senior leadership positions at the executive level, or as members of the board of directors.[6] Here's one that tends to shock people: In 2018, there were more male CEOs named James or John than there were female CEOs in the STEM industry.[7] Despite many firms adopting policies that promote gender equity in the workplace,[1] statistics show that the percentage of women in computing jobs (the 1991 version of tech) decreased from 37% in 1991 to 26% in 2014.[8]

By 2023, women held only 26% of technology jobs, and just 10% of those women held senior leadership positions.[9] Yet, studies show having women in management increases financial returns by 15-35%,[10] and further research has shown a lack of gender-diverse executive teams decreases company profit by as much as 21%.[11] What company can afford a 21% profit loss because it chooses to ignore the importance of gender diversity? Not a one.

What is the solution? Surprise! Women already cracked the code. In a 2022 study,[12] women argued that employer-provided social support would increase productivity. This was also noted in 2019[1] when women shared that social support improved motivation and

success in achieving leadership positions. White men, at this point you might be thinking "Women should be productive without a company providing social support." You would be wrong. Providing social support isn't being "overly accommodating" or catering to "sensitivity." It's leveling the playing field, paving the way for women to achieve their full potential, and showing female employees that their contributions and perspectives are just as respected (see also: diverse and invaluable) as Brad and Chad's. But I digress.

In my study, I cross-referenced the challenges identified by the women I surveyed with the social support experienced by those 80% of female leaders in tech with the ideal, supportive spouse. This book outlines the methods identified in my study that improve work-life balance and prepare you for career advancement. If you want to know how to have it all without doing it all, how to create the perfect spouse (no human partner required), and how to develop the social support you need to thrive, keep reading.

This book also discusses some uncomfortable topics and uncovers some hard truths. "Fix your face," "Watch your tone," and "Be more likable" echoed through my mind as I wrote this book. Maybe you've heard some variation of these. Heck, maybe you've *said* some variation of these (in which case, I recommend you read my entire dissertation—we've got some work to do). My response to this kind of language used to be an apology, more Botox (you don't need to fix your face if it's frozen), more silence, and more self-doubt. My current response is to suggest we focus on my accomplishments instead of my attitude. It's even in my email signature line in case anyone, me included, forgets. I hope this book enriches your life exponentially and helps you establish the social support and perspective that allows you to excel and expand—you deserve that and more.

When I Say…

In a popular song, "You Need to Calm Down," the Swiftie in me comes alive and to the defense of those who experience hate when they are just attempting to be GLAAD. This chapter marks my support and appreciation for those who are attempting to live their most authentic expressions of love and self. Like the song, this a clear message that this book is for all who are marginalized and a nod to their allies.

Before we continue, let me share the rules of the road. I invite all the people in the back to lean in and listen closely. When I say gender diversity, I am referring to all genders, including gender fluid individuals, transgender individuals, women, and men. When I say men, I mean *everyone* who identifies as male. When I say women, I mean *everyone* who identifies as female. When I say gender fluid, that means *everyone* has the right to self-identify. When I say partner or spousal equivalent, I mean traditional, non-traditional, and none of your business (see definition below). When I say *everyone*, I mean this book is written for all and inclusive of all. That means, men, while this book may feel that at times it has excluded you, stay with me. This book is also relevant for you; in fact, it is critical for you to read, process, and internalize. Hopefully, after reading this book, you will become more aware and effective in your allyship. With

that being said, allow me to provide some definitions that will help *everyone* navigate this book:

- ➤ **BIPOC:** is an abbreviation that stands for Black, Indigenous, and People of Color. For the purposes of this book (and in real life), BIPOC is the giant bucket of a label used to identify non-white people. At best, BIPOC terminology might be used to pad numbers to make it seem like a diverse, robust population is being represented. At worst, the abbreviation is an intentional reminder that the majority doesn't respect non-white people enough to count them as individual representatives of their specific group(s). It doesn't acknowledge the diversity within diversity and acts as a cruel reminder that the white majority does the "othering."

- ➤ **Diversity:** refers to the presence and inclusion of a wide range of different characteristics, perspectives, and experiences within a group, organization, or society. These differences can include, but are not limited to, race, ethnicity, gender, age, sexual orientation, socioeconomic status, physical abilities, religious beliefs, political beliefs, and other ideologies. Diversity includes those who are gender fluid, transgender, and any and all coupled (or throupled) partnerships. Embracing diversity involves recognizing and valuing these differences, promoting inclusiveness, and ensuring that various perspectives are respected and integrated into the broader social, cultural, or organizational fabric. Diversity also means you have avoided tokenism and truly embrace those who think, live, and love differently than yourself, showing that you have assigned value to every human experience and expression.

➢ **Equity:** refers to fairness and impartiality and implies providing justice according to individual needs, circumstances, and rights. It contrasts with equality, which focuses on treating everyone the same regardless of their individual differences. Equity aims to ensure that everyone has access to the same opportunities and receives the support necessary to achieve similar outcomes, thus addressing systemic disparities and promoting inclusivity. Equity can be demonstrated by the task of determining the height of a counter or chair relative to the individual using the counter. A 6'5" person needs a higher counter and a taller chair. If the counter is low, the tall person may experience back pain and discomfort. A 4'10" person needs a lower counter or shorter chair. If the counter is too high, the shorter person will experience discomfort and may not be able to access the counter. The counter and chair provide the exact same function, but the height of the person it was designed for comes with a built-in advantage. Conversely, those outside of the designed height contend with inherent disadvantages. Providing ergonomically correct chair pillows or creating an adjustable counter, for example, doesn't give anyone an advantage; it simply levels the playing field.

➢ **Gender-fluid:** refers to a gender identity that is not fixed and can change over time. Individuals who identify as gender fluid may experience a range of gender expressions and identities, moving between or blending aspects of male, female, and other non-binary identities. This fluidity can vary from day to day or over longer periods, and it is a valid and recognized identity within the broader spectrum of gender diversity. Gender fluid individuals might use a variety of pronouns, such

as he, she, they, or others, depending on their current gender identity. All individuals deserve and reserve the right to be flexible about their gender(s) without qualification or permission. The gist? No need for you to label them as male or female (also known as "none of your business"). In this book, when I refer to "men" and "women," I am also implying and including those who are gender fluid and may experience challenges as they land and move between their associations with either, both, or neither of those categories. It is important to note that being gender fluid does not mean you are free from experiencing marginalization related to traditional and specific gender identities.

➢ **Majority:** indicates the largest population represented. This may come with feelings of entitlement or privilege. For instance, the statement "They are taking all the jobs" suggests that the majority assumed ownership of these jobs, which are now being perceived as taken by the minority (others). In reality, these jobs never exclusively belonged to the majority, so they cannot be taken away.

➢ **Microaggressions:** are implied, indirect, and even unintentional behaviors or language directed toward members of a marginalized group (a.k.a. the everyday experience of the marginalized). If you're not acquainted with this term (which likely means you are also unaccustomed with the *experience* of being attacked via microaggressions), consider yourself privileged. Members of marginalized communities are all-too familiar with the term because it happens to us almost every day. Microaggressions might show up as being watched more than others in a store; being referred to as exotic (which is not a compliment—I repeat, *not a compliment*); being ignored in a meeting or having a

person from the majority pass off your ideas as their own; being asked to order food as a senior, female leader instead of asking a lower-ranking man to perform the task; being asked to run a Black History Month event because you're Black (after all, that means you must be an expert).

➢ **None of your business**: is a term I use to alert others that their judgment or acceptance is not needed (or wanted, for that matter) for the concept, thought, or experience I am stating to be true; if you, dear reader, happen to be one of the *many* individuals who need additional information to understand this terminology, I suggest you listen to Salt-N-Pepa's song "None of Your Business" for a step-by-step guide, because it truly is none of your business. Let me say it one more time, *it is none of your business!*

➢ **Social support:** refers to individuals, including friends and family members, who can be engaged during times of stress or crisis to provide emotional care, such as love and empathy. Social support keeps us from feeling isolated and overwhelmed. It includes everything from a friend's emotional support during a difficult time in your life, housekeeping services, monetary support, or someone delivering groceries to your front door.

The Help You Hoped For

A groundbreaking and popular show within the Black community and beyond, A Different World, has a recognizable theme song. It reminds us we've been told that things will be different. The world is not a clearly charted path, and focusing on your goals is key. This chapter describes how we are best able to define and reach our goals.

In a male-dominated workforce, and in some cases a female-averse workforce, the attrition rate and slowed career movement for women in leadership positions is staggering.[13] Women make up 26% of the workforce in technology companies and have an attrition rate of 76%.[14] Recognizing that the cost of replacing an employee is twice their current salary,[15] company leaders are proactively implementing programs geared at reducing attrition by supporting the well-being of their employees.[16] Mentorship programs have proven successful in the corporate sphere and have been linked to improved employee well-being. But what exactly does mentorship do, and how does it benefit marginalized employees?

I have had the privilege of presenting at conferences on topics ranging from equity for women and marginalized communities, to increasing corporate profits, to maximizing personal productivity. When I ask the audience to raise their hand if they have a formal

mentor, there's always an uncomfortable pause, followed by maybe 1-5% of attendees hesitantly raising their hands. When I stress that I'm referring to a *formal* mentor, some of them lower their hand completely or do some sort of uncertain half-up, half-down thing (like "What the heck is this lady talking about?"). I'm not just implying someone you admire at work who gives you occasional "career advice" on the down low (or on the DL, as those my age remember). Whether these conversations take place in the hallway, on the elevator, or via Slack, they are not private, likely a little risky (check your company policy, especially any verbiage about conflicts of interest), and rarely targeted to what *you* need for *your* personal and professional growth. You heard it here, folks: You need a formal mentor. Let's examine some common scenarios that show why mentorship is so important. Ladies, this stuff might sound familiar.

Have you ever been in a business meeting and had your idea repeated by a man? Co-opted by a man? Stolen by a man? So have I. Women are often pacified in situations like this (sometimes even by other women), calling the offending man's behavior an "innocent mistake" (feel free to roll your eyes with me). But if you or your contributions weren't even acknowledged, was it really so innocent?

Did you know what to do in this situation or were you caught completely off guard? Did you think about the incident days, weeks, or even months later? Did you start questioning whether it actually happened and if it did, why you didn't say something? Or, better yet, did you come up with a list of things you wish you had said?

If you were like me, you had no idea how to respond. At that exact moment, you didn't know how to communicate without being labeled an "angry, emotional woman," "one of those kinds of women," or even worse, "the angry Black woman." I cringe thinking back to all the times I said nothing. I'm embarrassed when I relive those memories. I am sharp, smart, and witty. At times, I am also silent. Knowing that sucks.

You need to be prepared for situations like this. You deserve to be prepared. A mentor will help you plan how to respond. They will role-play, share their experiences and wisdom, and diffuse any anxiety and stress you may have about these seemingly impossible business situations. As a marginalized person, you need to prepare yourself for challenges in the workplace, because they will come.

Let's dive into another example from my own journey. Earlier in my career, I thought I had it all figured out. One time, I took on an extra project as a strategic move, hoping to snag that "perfect" performance review and prove I could handle more responsibility. It seemed like a surefire way to gain visibility and maybe even secure a promotion. I was sharp and savvy on the front end of the project. I clearly identified my responsibilities, and even made a verbal agreement–recorded during a meeting–that someone else would handle the marketing piece of the project. I felt like I had set myself up for success, and I was eager for the challenge of this stretch assignment. That's not exactly how things worked out.

I was under the leadership of a new manager who hadn't been present when the team agreed I wouldn't be responsible for project marketing. My manager didn't have the context they needed, nor were they aware of the extent of the additional work I was tackling. These conditions created the perfect storm, and none of the agreed-upon marketing support came. It didn't happen…and wasn't going to happen. Decidedly in over my head, I geared up for the next meeting, armed with a clear list of what I needed from my team to move forward with this project. I laid out what I had already accomplished and what I was expecting as far as support and collaboration to the meeting attendees (which included one other woman and four men). Heck, I figured I might even get an apology for their failure to come through as promised. Instead, I was met with silence. The rest of the team started looking around. I was baffled. What were they looking for? Surely, they weren't looking for ways to pass the buck, sidestep accountability, and dodge the agreed-upon work…

"Isn't that your job?" a coworker finally asked me.

I couldn't believe it. Weren't we all on the same page? Wasn't everyone going to hold up their commitment to seeing this project through? It became apparent that the agreement I had made about the marketing plan was suddenly off the table. I was furious, frustrated, and disappointed, to say the least. I had poured my time and energy into this project, only to be hung out to dry by my colleagues. This project was set to be my crowning achievement in this role, yet no one else accepted responsibility. More specifically, the men in the room weren't accepting responsibility–for anything we had agreed on. The male coworker assigned to directly support the marketing plan was a popular individual, beloved by the organization and apparently untouchable, immune to any accountability. It quickly became clear no matter what this coworker of mine said or did, he would come out looking like a superstar (my mind drifts to the 'mediocre white man' troupe).

The meeting ended. Poorly. No one stepped up to support me, no one had any memory of the agreement (rather conveniently for them), and no one cared that I was underwater. Caring in the business world means you take action for the sake of the company–yeah, that wasn't happening. You best believe by the time I hopped off the meeting and took a deep breath I had a message from my new manager requesting a quick call "so we could connect."

Before that one-on-one meeting, I did what any organized, responsible employee would do; I found the old meeting recording and noted the timestamp where my former manager had promised I would receive marketing support. I had proof locked and loaded that I had been promised support. I was right, after all, and I had the moral high ground. I knew my new manager was going to support me and come to my defense to get everyone else in line. I felt more confident than ever going into that one-on-one.

My new manager opened the meeting with a concerned expression, and the first thing they said was, "that meeting fell kind

of flat" and "the energy got low." "Your face looked pretty angry" and "your tone was pretty strong" were also thrown out. Excuse me? What on earth did the look on my face have to do with promised resources being retracted? My righteous disappointment, redirection, and call for accountability were being characterized as "falling flat," "low energy," and having too strong of a tone? Was I an actress in a Broadway production with a director giving me notes? What performance was I supposed to have delivered? What had I missed? I was doing the sum of two full-time jobs by taking on an extra project. I had met every deadline, exceeded all expectations, and all my manager wanted to talk about was what my face looked like.

At this manager's direction, I apologized to the coworkers who had been at the earlier meeting, but I'm sure my apology felt as disingenuous as it was. The situation ultimately branded me as "hard to work with." I found it infuriating that the label targeted my personality and not my work product, but don't worry, we'll delve into that in a bit.

As I'm sure any person working in the corporate landscape can attest, it isn't unusual to take on additional work, be promised resources in advance, and then have those resources retracted. However common it may be, I wasn't prepared for this scenario at the time. I had never role-played this situation because I didn't have a mentor to coach me through it, but you can bet your last dollar I have one now.

My mentor has since helped me unpack this catastrophe of a business situation. He helped me see that I had been determined to prove I was right instead of charting a path forward and working collaboratively. I had wanted so badly to make sure everyone knew our team's major roadblock wasn't my fault that I ultimately appeared combative (you know the troupe; Black women are combative and aggressive, among other racist and sexist stereotypes). It was especially painful to realize that although my project execution had been on point, it was my approach to the lack of organizational

support that had prompted the most criticism. My mentor now shows me how to apply political astuteness without compromising my integrity, holds me accountable for improved communication, and prepares me for murkier waters ahead. Do better than I did: get your mentor ahead of your burnout, ahead of your challenges, and ahead of your career missteps.

Let's circle back to the root of my frustrations. Why was I labeled "difficult to work with" instead of being evaluated on my job performance? Why? What got people talking was my attitude, not the quality of my work. My perfectly justified disappointment and frustration over the lack of promised support were being weaponized against me. I was being labeled "that kind of woman." Cries for help were met with comments about my attitude and energy. There was no acknowledgment of the mountain of work I'd already tackled–alone, nonetheless. They just wanted me to plaster on a smile and be more "plucky." Give. Me. A. Break.

I will always wonder why management responded the way they did. Was it because I was known to be extremely capable that my manager assumed I didn't need additional support? Or maybe they assumed my age meant I could handle it all on my own. Perhaps it was because I'd never asked for help before, so they didn't realize just how badly I needed it. Was it because I was a tough, Black woman who could take the heat and "always had it together?" Was it because as a woman in business, I was so used to not asking for help and not showing weakness that I wasn't communicating my needs? Was it because I was truly out of line? I will never know.

What I do know is that trying to untangle this mess jumbled the thoughts in my head and tanked my productivity. With the amount of work, the lack of support, and the swirling of life around me, I had to take a mental health break. That break trampled on my established brand as the strong, hardworking female leader I am, and even made me start to question myself. It was painful, and it was necessary.

If you're a woman, I'm sure you, too, have experienced microaggressions by your colleagues. It's the little things that add up, the things you might later kick yourself for if you don't respond in the moment. You may even feel guilty about it. You may replay the scenarios in your mind at the most inopportune times. You know, the tape stowed away in the library of your brain that's labeled "Should." "I should have done this." "I should have said that." "I should have supported my colleague better." "I should have stood up for myself." But you didn't know what to say. You "should" all over yourself, and while you're replaying that interaction over and over again, you aren't strategizing. You aren't being productive. "Shoulding" has no value and no place in your life. It's the last thing you need. I know—avoiding the "should" trap is far easier said than done. I'm sure you can guess where I'm going with this…

Time for a mentor! They'll help you proactively navigate the situations where finding the "right" thing to say seems impossible, whether that manifests as a micro- or macroaggression. It's ok to not be an expert in handling marginalization. You have permission to be pissed off about it without producing a flawless response. You also have permission to stand up for yourself in a productive way, to show up as the best version of yourself, even when others try to tear you down. Find yourself a mentor, so the next time you experience a microaggression (in the workplace or otherwise), you can show up, stand up, and be heard. You never know—you might even inspire some change in the process.

Here's the big question: who is the best person to be your mentor? When I started my doctoral research, I expected to find that the best mentors for women would be, well, other women. That wasn't the headline. Instead, white men stole the headlines as the heroes who came through for the majority of the women who participated in my study. Admittedly, I was surprised at first. Then I thought about the white men who have shown up to support me during pivotal moments in my career, namely a man named Dan.

Allow me to introduce you to my mentor, affectionately known as Employee #6. A white man with extensive knowledge and experience, Dan Tyre was the sixth employee at a company where I was employed. He could easily be considered a "dream mentor." Dan is personable, successful, wealthy, well-connected, and an inspirational leader known for his positivity and kindness. He took me under his wing, invested in my career, and helped me gain perspective when I needed to adjust my mindset. He is also more aware than most about the obstacles the BIPOC community faces (perhaps even more aware than some who are part of the community themselves). As Zora Neale Hurston said, "All my skinfolk ain't kinfolk."

When I shared my struggles with Dan, he didn't even flinch. He proactively calls out bias without excuse or justification. Because of his high-level experience, he knows what goes on behind closed doors, and he knows how to navigate the microaggressions that pop up without warning. You need a Dan Tyre—someone who knows the trail, has extra supplies, and believes you deserve to climb the mountain.

To this day, Dan refuses to charge me for his incredible direction and support. His only request is that I buy him a breakfast sandwich when I achieve a new goal—I'm always more than happy to do so. White men can and do show up. Based on my own experience and the lived experiences of the women included in my study, the automatic dismissal of white men's allyship and effort may need reexamination. The BIPOC female participants from my study, specifically, shared several examples of white men who had opened doors, cleared paths, and taken action to elevate the visibility of women's work.

Research shows women are 56% more likely and men are 93% more likely to get jobs if they have a mentor.[17] While the scenarios you prepare for might be different, mentorship is just as important for those of you who identify as men. Allow me to pose a question

21

to my male readers (you are brave, you matter, stay with me): Have you ever been in a meeting where a woman shared an idea you disagreed with? Did you avoid voicing your opinion because you were nervous about potential backlash? Did you suck it up because women have listened to bad ideas coming from men for decades (I would love to insert a stat here but let's just call this 'not science' and confirm it is an irrefutable fact)? Perhaps you didn't want to be viewed as "that guy." Maybe (hopefully) you truly support women and don't want to participate in their marginalization. Your silence, however, is not the answer, and I assure you women aren't looking for a free pass to elevate bad ideas. That doesn't help women, men, or the company.

On the other hand, you might also find yourself in a scenario where a woman or member of a marginalized group is being ignored. How do you advocate for that person? How do you create space for them without alienating your colleagues or being labeled as too extreme? These are valid fears, concerns, and challenges. You need a seasoned mentor to help you navigate these circumstances with clear communication and a targeted focus on the idea, not on the gender of the idea's presenter.

Make sure you hear me and seriously consider this truth: to advance your career; to reduce your stress and anxiety; to be more productive; to finally get that seat at the table; to know what to say when you get to the table, *you need a mentor.* Take advantage of mentorship programs and other company resources. If your company doesn't have a mentorship program yet, consider seeking out a formal mentor yourself. Easier said than done, right? Nope! This one is easy—just ask. Asking someone to be your mentor is a huge compliment, so ask with confidence and sincerity. The conversation may go something like this:

"Tynisha (if the name throws you or feels unexpected, check your bias first, and then keep reading), you have been so effective in navigating your career at this and previous organizations. I admire

the way you handle high-stress environments and make the best of difficult situations. I was hoping you would be willing to mentor me so I could develop similar skills. I realize you are busy, and I'm committed to joining each meeting prepared to listen and learn. Is this something you would consider?"

Well, what are you still doing here? Go get yourself a mentor!

Reflection Questions:

1. Who do I admire in my network?
2. Who is currently in the roles, fields, or communities that I want to join?
3. Which leaders could I connect with and learn from?

Next Steps:

1. Considering your answers to the questions above, create a list of potential mentors.
2. Connect with the individuals on the short list and ask them to be your mentor. You've got this!

The Work-Life Wobble

In her hit song "Loving Me," Janine voices the struggle we all face trying to love ourselves as much as we love everyone else. Let's make the conscious decision to finally give ourselves the self-care and respect we deserve, despite everything we've been through.

As I was doing research for my doctoral program, I came across a staggering statistic: there has been a whopping 38% decrease in work-life balance for women since the COVID-19 pandemic began.[12] For my fellow ladies out there, that translates to 38% more grind, 38% more housework, and 38% less "me-time" every day. So yeah, you might be feeling 38% more wiped out, 38% more on edge, and probably 38% less patient with everything and everyone. Take a second to let that sink in. I'd join you but I've got some laundry requiring my attention. And nope, I'm not joking. I get it, you might be multitasking too, flipping through these pages with one hand while folding clothes with the other. Here's to hoping you can still find where you left off reading with 38% less time to spare.

Now, 38% might not sound like a big deal at first glance–it's not even half, right? But imagine slashing your morning routine by that much. As a work-from-home regular, my timeline from hair-

scarf-off to Zoom-ready is about 20 minutes. Doing some back-of-the-napkin math (or using Google–your choice), if I decreased my morning routine by 38%, that would give me 12 minutes and 40 seconds to get ready in the morning. Trust me–you don't want to see that chaos.

I talk to large groups of people about work-life balance like it's a don't miss Beyonce drop at midnight. One daily requirement is being uncompromising in your self-care every darn day. Don't negotiate on that, especially when the new focus on performance culture is real and everyone's counting your output. Self-care is not just fluff–it's hard science.[18] Turns out, caring for yourself isn't a luxury; it's a necessity for keeping the corporate wheels greased. The workplace demands we deliver top-notch results. But guess what? You can't pour from an empty cup. Research backs this up: neglecting self-care is a fast track to burnout city, not a productivity boost.[19]

Nowadays, thanks to that work-from-home life, a staggering 85% of remote employees are sneakily tackling chores between Zoom calls.[20] If you're busy doing chores, that means you aren't strategizing. That means you aren't going into meetings at your best. Have you ever been so deep in laundry duty that you blanked out during a meeting? Yeah, me too. It's a struggle when your head's in the spin cycle and you're supposed to be discussing quarterly goals. As one woman from my study put it, "I'm working and trying to focus on my career (but it is hard) if I know there's laundry piled up in the background."

Ever find yourself pretending to work just to dodge your endless to-do list? Me too, as does one of the women from my research: "There are days I hide in my office not to tackle dishes. I feel like I have to decide if I should work versus if my house is clean."

I feel this down to my core. Let me tell you, I've had pneumonia more than once, and guess what? It has always happened when I

was married—when I should have had my partner's support and a lighter load. But that wasn't my reality. When I was married, I was so busy trying to be the "perfect wife" (whatever that is) that I ended up burning myself out. I took on every responsibility, shrinking my own definition of success to the size of a dust particle (seriously, the time I spent dusting could've earned me five more degrees). The lack of support from my partner would've been manageable if I had known how to build or outsource the support I needed. My health would've been better, my work would've been better, and I probably would've been a more pleasant person, but when we put ourselves last and let our work-life balance go out the window, our bodies have a way of saying "enough." Take a moment to exhale, breathe, and remember that you deserve support and a break too. This participant said it best:

"If I wasn't doing laundry and dishes between meetings…I would probably prepare for my next meeting, go for a walk, read, just exhale."[20]

Wow! Just exhaling is a luxury at times, right? Remember what happened with Bernadine, Angela Bassett's character in *Waiting to Exhale*? Since I live close to Scottsdale and recognize the danger of a fire, please take a moment to exhale, because in reality, you don't get to light the match, toss it on the pile, and walk away. To avoid that cinematic moment, go take a much-needed walk. Figuring out when and how to breathe and take that walk means making a commitment to improving or establishing your work-life balance.

Let's be real: Sometimes, you need to grind from dawn till dusk. But those days when you technically could work less, do you *really* unplug? Does anyone genuinely work just eight hours, especially as a remote employee? When the office is steps from your bed, it's hard to know when to call it quits.

The reality is that most of us plan for an 8-hour day, end up working 9-10 hours, and then squeeze in extra tasks "really

quick." Suddenly, it's a 12-hour day, and you're running on fumes. Exhaustion sets in and the next day, you're irritable, less productive, and ready to job-hop because you're so burnt out. Continue down this path and you start feeling dissatisfied enough that you consider looking for a new job. Remember, attrition is not just expensive for companies; it's also expensive for you, because the job search is exhausting. Fun fact: Exhaustion is not a badge of honor.

So, here's what I suggest you do: Schedule a 9-hour workday. Take a lunch break. Seriously, do it. Schedule at least one 15-minute break where you're not doing chores, not eating lunch, not strategizing, but just being. Use those 15 minutes for a walk, a quick yoga session, or some trashy TV. Prioritize *yourself*. That's self-care. Take the time to clear your mind–not your house–of junk and refocus on what matters most. This should happen daily, it should be at the front of your mind, and it should be important to you (I know, shoulding on you, again).

After eight hours, start wrapping up. Use that shiny, new ninth hour to prepare for tomorrow instead of working until you drop. When you can work less, do it, and ditch the guilt. On busy days, be honest with yourself and set boundaries for the next day. Leave work when you're done. What a concept, right? Even if your commute is a 30-second walk to the kitchen, establish a clear boundary between your personal and professional lives. Close your office door, shut your laptop, and switch off. Create a "leaving work" ritual. Mine involves changing into pajamas (my "commute" home) and refreshing my drink. Maybe for you, this looks like taking a shower, making yourself a snack, or watching the latest episode of your favorite TV show. There's no wrong answer here, as long as your "leaving work" routine involves no work.

Congratulations! You've scheduled your 9-hour workday, handled chores strategically, taken your lunch break, and carved out time for yourself. You're proactively balancing work and life.

Action Plan:

1. Update your calendar to accommodate your 9-hour workday.
2. Schedule a *real* lunch and *at least* one 15-minute break.
3. Think about your "commute" and what your leaving work routine will include (if you have one already, you go, girl!).
4. Start a list of the chores you do between meetings (and keep those handy for the next chapter).

Building the Perfect Partner (No Human Required)

This chapter is a love letter to the partners who have learned how to support strong women. In her song "If it Wasn't for Your Love," Heather Headley tenderly describes what's possible with true support. The fairy tale isn't about the kiss of a prince or princess. The fairytale is in the support they give you to fly and the space for you to embody a light that is so brilliant it's blinding.

As I shared earlier, when I started my research, I was blown away by the statistic that 80% of female leaders in tech attributed their success to a supportive partner.[1] Really? So basically, the secret sauce to success and work-life balance is finding a super supportive partner (cuffing season, all year round)? Teamwork makes the dream work, after all. But then I started interviewing women in tech, and guess what? Their stories didn't match that 80% statistic. Turns out, having a "supportive" partner is as elusive as a unicorn. My own life reflected this too. Just finding a partner wasn't the golden ticket to career success and work-life balance.

Let me be truly transparent here. At the age of 40, I had no degree and three unsuccessful marriages. My last husband told me,

"You are too Black and too liberal to be my wife." Ouch! After almost a decade of supporting him, his words cut deep. How had I given and done so much for this man just to receive so little support in return? I had doubted myself, sold a successful business, moved across the country, and recovered from his cheating (again), yet I still wasn't enough. Or maybe (in retrospect, definitely) he wasn't enough. How could I have set myself up for success without relying on an unsupportive spouse? Another failed marriage screamed that I hadn't cracked the life code. I needed support. Hence, this book.

I wanted a partner who didn't cheat and actually wanted me to thrive. I craved the same success those 80% of women leaders had achieved with their supportive spouses. But dating apps (Hinge, Black People Meet, Tinder, Plenty of Fish—you name it) taught me that hoping to stumble upon Mr. Perfect wasn't enough. But, back to the research.

I realized there were two sides to this coin: identifying what makes a supportive partner and recognizing who's been dragging us down. One of the questions I asked the women in my study was "Who has discouraged you?" One response in particular haunted me, because prior to 2021, I would have said the same thing: "Every man I've ever dated, and my ex-husband." How many of us can relate to that? How many of us would respond the same about our past or present relationships? How many of us have dimmed our light for the sake of companionship or so-called security? Or perhaps, we just relate to the absence of a cheerleader, a person who says, "She can do it" and has unwavering admiration for your talents and abilities; a person who does not associate a woman's worth with the cleanliness of their home, their production and maintenance of children, or the circumference of their waist.

Partnership needs a clear definition. What do those 80% of women leaders in tech have in a supportive partner that helps them succeed? My research showed that lack of support hindered leadership motivation and heightened work-family stress. Understanding this

relationship is essential to promoting women's involvement and empowerment in technology leadership. I knew I couldn't, in good conscience, tell people (specifically women) to just find a partner. With three failed marriages, I know how bad marriages can hold you back.

Forever the optimist, though, I ultimately remarried, this time to a truly supportive spouse. With his cheerleading and support, I went on to earn the right (and requirement) to be called Doctor. The right partner can be life changing. They help you evaluate career advancement opportunities, workplace dynamics, and perhaps most importantly, create the space you need to navigate a treacherous corporate landscape. But simply having a spouse isn't the answer. I needed to understand exactly what a supportive partner does.

By asking women what they needed (that's right, women know what's needed), I identified the daily actions supportive partners take that promote work-life balance for women (and the magic that support facilitated). These included tasks like picking up groceries, meal planning, laundry, caring for elderly parents, and managing the kids' schedules. Supportive partners help chip away at the 38% of additional work.

Everyone's situation is unique, and my experiences might not hit home for you. Sure, having a supportive partner sounds fabulous, but let's be real: many of us have dealt with partners who are anything but supportive. So, what if you're single or your partner is more of a burden than a boost? Whether you're flying solo or stuck with a partner who's not pulling their weight, I've got you covered. It turns out, you don't need a human partner, you just need to build up your social support network.

What does that mean? It means rethinking how you spend your money and investing your resources to support your work-life balance. Working from home has changed the game. You still need and deserve a clean office, even if it's just a corner of your living room. No one would start vacuuming their corporate office

in the middle of the day, so why are you doing it at home? Stop vacuuming, dusting, mopping, and any other type of chores. For real, stop it. It wouldn't make sense to do it in a corporate office, and it doesn't make sense if your commute is from your bedroom to your desk three feet away. Between meetings, you should be strategizing and preparing for your next meeting, not dusting the corporate workspace. Outsource the housekeeping, even if it's just once a month.

Now, a shout-out to the men. This section's for you. I know you're feeling the pressure of being "underfamilied." Men, and those who identify as men, are seriously missing out on family time, and they want to be involved just as much as women do. Women are expected to spend time with the kids whenever they get a spare moment, like in those dreamy laundry detergent commercials where they're reading to their kids in a meadow after a grueling 12-hour workday. Meanwhile, if men get a spare moment, they're expected to log more hours and squeeze in even more work. This needs to change. Men deserve to be seen as active caretakers, fully involved in the household, both for their own wellbeing and for the benefit of women.

When men get an extra hour, they're expected to fire up the laptop and grind some more. Imagine if instead, they took that time to swap the laundry or help with the dishes. If men started balancing work and home chores, women would have more time to strategize and practice self-care. It's almost like we're supposed to work as a team—crazy, right?

Partners should share the load at home. But if that's not working out, or not available, there's always outsourcing. Everyone deserves more time to be productive at work, and that means finding external help for the chores we shouldn't handle alone. So, men, keep reading because you're crucial to this movement!

We all need to invest in self-care, which is fueled by a good work-life balance, partially achieved through outsourcing. But

outsourcing can be pricey, and this book doesn't come with a magic money tree. So how do you afford it?

Since we're all friends now (#tribe), let's get real. Do we really need any more dress pants? Workplaces are so much more casual now, and with so many of us on Zoom, no one even sees our pants! Honestly, who knows how many times you've worn those slacks without washing them, or dry cleaning if you have remnants from the in-office days? I hope I'm not alone in embracing the wear-more-wash-less lifestyle...unless, of course, we're meeting in person.

Let's talk makeup. The expensive stuff? Nah, we can skip it. Good lighting is all you need. Invest in a solid ring light, position yourself so you're facing a window, and voilà! Insta-glow. And pricey perfume? If it's just you sitting alone in your home office, who are you trying to impress?

And let's not forget those expensive shoes that no one sees anyway. Instead of splurging on another pair of uncomfortable heels, let's redirect those funds towards things that actually improve our work-life balance. I bought a pair of red-bottoms to defend my dissertation and haven't worn them since–should've spent that money on house cleaning services. But cutting out fabulous shoes completely? Cruel and unusual punishment. Let's just buy fewer of them, ok? Shoes can be life-changing, after all. But back to the point, let's strategically repurpose our resources. Invest in what you need and ditch what no longer serves you. So, what does serve you? Simple: anything that helps you achieve a better work-life balance.

Social support systems are key to advancing women's careers, especially in technical fields.[21] Women with strong social support are more resilient at work.[22] A supportive partner can make a huge difference, but not everyone has that person. So, let's create that support with our financial resources. You can get the benefits of a supportive partner without actually being in a coupled relationship.

For example, need someone to pick up ketchup for your fries? You might not want to bother a friend, but you can order it on

Instacart. Instead of spending on pants and makeup, get an Instacart subscription. Make your life easier and give yourself space to breathe between meetings, instead of stressing over finding time for that quick grocery store run later. But is a quick trip to the store really ever that quick? I think a drive-through grocery window is well overdue.

Sometimes having social support is about more than just convenience. Sometimes it's critical, especially when you're a single mom with two young kids. Let me tell you a story from my life that shows just how vital a created partnership–not necessarily a romantic one–can be. It also shows the train wreck that is having no support or, worse, an unsupportive spouse.

Picture this: winter in Wisconsin. Yes, it was very, very cold. Why was I there? Blame military relocation, but that's another story. Anyway, I got the flu for the first time ever. And not just any flu. This was the "every hair follicle on my head hurts" kind of flu–not an exaggeration. Breathing made my lungs feel like they were on fire, and the freezing cold only made things worse. I somehow dragged myself to the doctor, tears streaming as I described my symptoms. Their sympathy level? Let's just say a brick wall would have been warmer.

They handed me a prescription, and I staggered to my car. Exhausted and in pain, I still had to pick up the medication from the grocery store pharmacy in town. I could barely stand, let alone safely navigate icy roads. The worst part was that there was no one to help me. Yes, I was married. No, there was no help. My husband at the time was "at work," but strangely unreachable on his cell phone. Turns out, he was busy "helping" someone else. The panties in the washing machine that weren't mine and the condoms in the back pocket of the Range Rover weren't the subtlest of tip-offs. But back to the flu.

Here's the bottom line: without social support or a supportive partner, you are forced to do everything yourself. The idea of sending my 7-year-old son to the store on his bike through two feet

of snow was not even an option. Even if the pharmacy was willing to give him the prescription (highly unlikely), the icy, busy road was far too dangerous. For context, winter in Wisconsin is so cold that you can throw a pot of boiling water in the air, and it will turn to mist instantly. No way was my kid biking in that!

I somehow managed to drive myself to the pharmacy. I remember grabbing a single-serve orange juice and then just staring at the clerk. I had to ask her to open it because I didn't have the strength to twist the cap. At that point, I was too sick to care or be embarrassed. I stood right there in line, opened my meds, and swallowed the pills on the spot. Why? Because I was terrified that if I waited until I got to my car and choked, there'd be no one around to help. Talk about a low point.

The fact that I had no one to support me was glaringly obvious. My only friend in that new town lived 20 miles away and asking her to come out in that weather felt like too much of an imposition. I don't even want to think about how many people I might have spread the flu to that day. I tried not to be a burden, while also hiding my situation because I didn't want anyone to know how little my husband supported me.

To this day, I hope that poor cashier didn't catch the flu from me. Honestly, I debated not sharing this story, but since we're all friends here, you deserve the truth. This story highlights why it's crucial to set up social support systems before you desperately need them. Whether you're single, married, or somewhere in between, you need to create your own "perfect partner" by utilizing every resource available to you.

These days, we have delivery services like Instacart and Uber. I could have minimized that ordeal with a little help from these services. It could have been a minor blip in my memory, but experiencing it taught me the value of having social support, whether paid or offered. So, before you tie yourself to someone who isn't worthy of your time, energy, or brilliance, deeply consider

whether they're supportive. Are they taking care of your needs, or are they too busy taking care of their own–or someone else's? If that potential partner can't cheer you on and have your back, take a hard pass. Instead, order Uber Eats. It's a lot less expensive than an unsupportive spouse.

Here's another idea for you: use the money you're saving on commuting to invest in laundry and house cleaning services. Don't see this as a luxury; it's an equity play. Work-life balance boosts productivity, which in turn increases corporate profitability.[23] The better your strategy and outcomes at work, the faster you get promoted. You deserve to shift resources to create an equitable experience for yourself–so do it! Consider this book your backstage pass to a kick-butt work-life balance. Share it with your judgmental mother-in-law who swears by scrubbing her own floors. Quote it when someone scoffs at your supposed "bougie lifestyle." Relish it when you nail that presentation because you actually had time to craft it into a masterpiece.

Let's pause and reflect on the small changes suggested so far. They're the keys to monumental shifts in your life. Imagine your place: tidy as a pin. Laundry? Handled and neatly folded. Your work hours? Totally sane and manageable. Stress? Barely a blip on your radar. You, my friend, strategizing like a boss and conquering your goals left and right. Plus, your mental health is soaring high. And hey, maybe even scoring some quality time with the people that matter to you. But hold on, we're just getting started!

I uncovered two crucial areas where partner support plays a massive role, especially for women in the tech world. My research shows that these areas hit women harder because of outdated gender norms and a lack of support systems needed to facilitate their success in leadership roles.[24] But keep in mind, these issues can truly affect anyone, regardless of how they identify.

Now, allow me to paint a picture with a story from a summer of my life that was straight out of a country song. Picture me living

down a very rural, very long dirt road, surviving on nothing but cherries and packages upon packages of Lifesaver mints (peppermint-flavored, to be precise). I had horses and mini horses, and I spent my time mucking stalls in the sweltering heat, dodging electric fences, and keeping my little rescue Chihuahua from becoming a coyote's dinner.

I had recently split from my husband (remember the one who was AWOL while I had the flu?), who was more interested in his Range Rover and other pursuits than, you know, being a decent partner. In a glorious act of revenge for the repeated cheating, lack of intimacy, and total abdication of care and concern for his wife and family, I exacted revenge by stripping every material possession out of the house–down to his leather recliners and mini fridge. Although I feared his reaction, particularly when he discovered the man cave makeover, the experience was therapeutic. I probably shouldn't be smiling as I write this…but I am.

When I think back, I'm not quite sure how I pulled it all off. I worked full time at a kennel supervising a doggie play yard, outside all day every day in the hot sun and humidity. I would come home to our trailer and take care of my little farm and my two kids. We were poor. Food, energy, and time were limited. To keep sane amidst the chaos, I leaned into yoga and my cherry-Lifesaver diet. Yoga kept my mind off the drama and filled the long, lonely days. But let me tell you, I was running on fumes–skinny, tan, and utterly exhausted.

Now, why am I sharing this story? Because it's about more than just surviving on fruit and candy. It's about the need for real sustenance to fuel success in any field. Back then, I was too drained to cook proper meals, let alone plan them. If meal kits had been a thing back then–pre-planned, delivered to my door–I could have saved myself an immense amount of stress. I could have saved valuable time spent determining which meal I was going to make for my children (no, they weren't eating mints and cherries) and

which ingredients I would need. I also would have saved money by purchasing exactly the amount of food we needed.

Meal kits, tribe! They're like having a personal chef hand-deliver a balanced, home-cooked box of goodness with everything you need to whip up dinner in 30 minutes flat. No more wandering aisles, no more takeout guilt. Just wholesome, stress-free eating that actually saves you cash. And let's not forget the bigger picture here. We're still wrestling with outdated gender roles that unfairly burden women with the lion's share of domestic duties, like cooking. It's time we all step up and share the load, regardless of our pronouns or biology. We can do better, and meal kits are just one tasty step toward leveling the playing field.

Alright, let's break it down in a way that's as straightforward as ordering a meal kit:

When I clock out and slip into my PJs at the end of the workday, the last thing I want to do is brainstorm dinner options or hustle to the store for a missing ingredient. That's where meal kits swoop in like the superhero partners I've created for myself–no human partner required.

To state the obvious, you don't need a spouse or a partner to enjoy the perks of meal kits. I mean, hello, I've conjured up my own culinary companion just by signing up. They bring the recipes, do the shopping, and drop everything off right at my doorstep. It's like having a sous chef who never talks back!

I can tell you from personal experience having this "phantom partner" is not just convenient–it's a strategic move. My stress levels have plummeted now that I'm not surviving on Lifesavers and cherries alone. I'm eating real meals that fuel my brain cells to function at their peak. Plus, all that time I used to spend planning and prepping? Now I can funnel it into things I actually enjoy. But wait, there's more to this equity play! You can extend the partnership model to other chores too. Rotate who cooks, who cleans up, and

who handles leftovers. It's a choreography that keeps things fair and keeps you sane.

And here's the kicker: If things ever go south with your meal kit service, no messy breakup drama. Just cancel the subscription and move on. It's like dating without the emotional baggage–single folks, take note! So, whether you're flying solo or hitched, meal kits are a game-changer. They're not just about dinner; they're about reclaiming your time and sanity, one delicious meal at a time.

Next Steps:

1. Make a list of household chores and who is responsible for them.
2. Calculate the amount of time you spend on each chore.
3. Make a list of "extras" you pay for (makeup, perfume, grocery bill, subscriptions, etc.) and rank them in order of importance.
4. Decide which ones you can give up so you can invest in work-life balance.
5. Revamp your budget to outsource the tasks you can, and if possible, redistribute the remaining tasks equitably.

And There's More–
There's Always More

Marriage: I Do…Need Support

Many of us have been told directly or experienced the sly messages of marrying well. This is the topic of the song "Round Hole," by Rebecca Brunner and Song House. Guess what? Not choosing that path is ok. Not following "the plan" is ok. Making choices that insulate and promote your career path is ok. No need to get a minivan if that is not your calling, and if it is, we collectively support you as well.

As part of my research, I dove headfirst into the rollercoaster of how marriage impacts women's careers. Decisions about tying the knot (or not), starting a family (or not), dealing with leave policies, disability benefits, and juggling home and work life are all life-altering. Bottom line: marriage can seriously mess with your career path.

One of the participants from my study shared that her marriage revolved around boosting her husband's career, leaving her own dreams gathering dust. I'd never make that mistake–except for those ten years I totally did (insert eye roll). How do you juggle supporting your spouse's career, especially if theirs is paying the bills,

while chasing your own ambitions, which are just as important? The stakes are sky-high, and the fallout can be grave. One study even found that when women get promoted, divorce rates go up, but the same isn't true when men are promoted.[25] So, who gets their shot at success first, and how do you keep your marriage intact when it's finally your turn?

One woman said, "I turned down a potential position for me because I want to make sure I am home for family balance."[20] Translation: I need to be home to make dinner. And yes, I get the importance of family meals. But sometimes it feels like every decision is a catch-22, riddled with conflict at every turn.

Now, throw in the military spouse dynamic. The non-serving spouse's career is expected–scratch that, required–to take a backseat because of frequent moves (hello, Permanent Change of Station, a.k.a. PCS). "Yeah, getting married, choosing to marry somebody in the military, that has created a significant challenge," one of my study participants shared. Military careers can last as long as 20 years. That's two decades of taking the backseat. Plus, if you choose not to work outside the home, your career growth hits a wall with every move. This is why remote work and flexible hours are critical–they're not just perks; they're an essential equity play.

Having been married to two military men (who wouldn't know social support if it bit them and couldn't care less if they did), I can tell you, moving your life and restarting your career every few years is no picnic. How do you climb the career ladder when you might need to relocate to another country with little notice? I knew women who earned more than their military husbands (not hard to do considering how little we pay our troops), and they still had to leave their careers behind for their spouse's military service requirements. You might be thinking, "But they signed up for this!" or "It's an honor to support your spouse in service to our country." Sure, but two things can be true at once. You can be

proud and honored, and still crave equity, personal success, and a stellar career.

If you're already living this tough reality, you're probably asking, "What now?" My advice is to build a robust social support network to create more room for connection at home. A spotless house won't save your marriage. Take it from me. But the stress and distraction of maintaining that spotless house might spark marital conflicts. Outsource as many chores as you can and use that freed-up time to connect with and appreciate your partner. When both partners feel their needs are met (regardless of who's doing the dishes), your relationship has a better chance.

Having a mentor can be a lifesaver, reducing workplace stress so you bring less tension home. When the corporate world feels less like a minefield and more like a mapped-out journey, you can breathe easier. This creates a calmer home environment, allowing you and your partner to uplift each other more effectively.

Now, let's say you've tied the knot, you're cheering on your spouse, and you're hustling for your own career, too. High fives all around! You're meeting your Mentor regularly and feeling pretty good about juggling it all. But just when you think you've got this marriage-career balancing act down, here comes pregnancy to throw a curveball. Here's a spoiler: it doesn't get easier.

Let's reflect:

1. Check Your Support System: Reflect on how your spouse is really supporting you. Are they stepping up, or just coasting?
2. Career Boost or Bust: Think about how your marriage is helping (or maybe hindering) your career. Is your partner a cheerleader or an anchor?
3. Ditch the Perfection: Identify the home tasks you're obsessing over that don't need to be perfect. Does the

house really need to be spotless all the time? Nah, clean is good enough.

4. Speak Up: Sit down with your partner and lay it all out. What do you need from them to keep your marriage strong and your career thriving?

Pregnancy:
A Bump in the Road

Beyonce told us that Girls Run the World. We bear children and then get right back to work. Incredible the amount of resilience, speed of healing, and mental fortitude encompassed within the 'weaker' sex. It is a dangerous thing to underestimate a woman. It is even more dangerous to not provide the resources they deserve. This chapter is about the lack of resources and the cost to literally propagate the human species that is unevenly distributed to women.

The lack of paid maternity leave came up a lot in my study, and it's no wonder why. Take one participant, for example: she's got a bachelor's degree, kids, and a spouse, and she really struggled with balancing time off for childbirth and keeping her job. She wanted more time to heal after giving birth but rushed back to work after six weeks off, fearful of the career backlash if she stayed out of the office too long. "I returned back from leave as soon as I could, so I didn't take any additional time," she said.

Six weeks off. That's it. Even though your body needs at least six months to recover from childbirth.[26] Six months to recover from creating life, but only six weeks off? That's nuts. And let's

not forget about the time before birth. Many women work right up to their due date, carrying a whole other human around. I, too, worked until just two weeks before my due dates. When I was pregnant for the first time and working at AT&T as a temp, I hid my pregnancy, scared they wouldn't hire me. Despite being the top temp, I feared I wouldn't get hired. Guess what? In 1995, I was right. I only announced my pregnancy after I was hired on permanently, and my new manager hit me with, "So you aren't going to be around to do the job we just hired you for. Good thing you have a Union." At 22, I didn't grasp exactly how messed up that comment was.

Another of my research participants said she couldn't risk switching jobs because she needed the FMLA leave. She stayed put just to ensure she'd get maternity leave. How does this make sense? Women constantly compromise their careers for the sake of the family and their significant others' careers. Yet when it's our turn to be in the spotlight, to have the specialized and exclusive task of childbearing, shouldn't we have the most support? Women deserve more than just "adequate" (if you can even call six weeks adequate) paid time to heal. We're literally bringing new life into the world! Rushing back to work right after giving birth? Come on. We need time to breathe and recover.

While we're at it, can we talk about nursing? A collective facepalm for all the women who've had to pump in a bathroom stall. And those "lactation rooms" that are actually storage closets filled with cleaning supplies and no chair in sight? Please. As recently as 2019, major companies were still using these rooms as storage (shoutout to Mamava for creating pods that give nursing mothers a clean, private space–they deserve a massive thank you).

And what about post-labor complications, or pregnancies that don't go full-term? These women get even less support and time to heal. Without a newborn, they're often overlooked. Microaggressions in the workplace just add insult to injury. The insensitive and

downright inappropriate comments can seem endless. Another woman from my study told me, "I had a miscarriage. [My boss said] 'Sounds like you're looking to grow a family,' [and] at this time I was not married. It wasn't a planned pregnancy." Imagine having a miscarriage, dealing with the heartbreak, and then facing a boss who assumes you're starting a family and makes snide comments about it. Talk about a total jerk.

Economic and career pressures push many women to delay having children. Makes sense, right? Especially when you consider that 43% of new mothers leave the tech industry after having their first child.[27] That's almost half! The fact that so many women would rather give up a lucrative tech career than navigate the workplace post-baby is chilling. Those who stay in the workforce face a hostile landscape full of compromises. Balancing work with motherhood is a guilt trip on steroids. One participant shared:

"I was offered a position in 2015 that would have required travel 3 to 4 times a quarter, and my daughter is just turning one and was starting to notice that I was absent."[20]

She was thrilled about the role but had to pass it up. During my research, I found that 100% of women wanted to advance in their careers, but 90% had passed on promotions or better jobs at some point. The obstacles women face in career progression, spousal support, and childcare are daunting. And no, it's not as simple as "they chose to have children." Again, two things can be true: you can want kids and an equitable, fulfilling career.

After all this collective trauma, let's discuss solutions. Allies, it's time for you to lean in. If you're established in your career and have some "social currency," so to speak, start asking your company the tough questions. If you're a superstar or a favorite, push your HR department on their policies and benefits. When you're interviewing for senior roles, make it clear you're looking for a company that values its employees and offers generous leave for both women and men after childbirth. Even if you're past childbearing years (like

me), it's crucial to reach back and make it better for those coming up behind us.

If you're currently in the thick of it, take your full leave. Document any unfair treatment or discrimination related to your pregnancy or leave. Support other women as they prepare for and return from leave. Speak up against slick, disparaging comments about women on leave. Apply pressure to break down the walls and ceilings holding us back from equitable treatment.

Sure, generally speaking, men can lift heavy things, but that's not all they should do. And while women can bear children, that's not all we should do. If a woman does choose to have children, however, navigating the workplace is a whole other challenge we shouldn't have to face alone.

Food for thought:

1. Check if your company offers mental health counseling as a benefit–it's a game-changer.
2. Take every bit of maternity leave you genuinely need, and don't let anyone guilt you into cutting it short.
3. When you're scoping out your next job, make sure their maternity leave is up to snuff for your current and future plans. If they're not cutting it, keep on hunting.
4. Outsource whatever you can to free up time for you to rest, heal, and recharge. You've earned it.

Childcare:
Diaper Duty and Other Dilemmas

Sara Bareilles shares with us all the loss of self that can occur in "She Used to Be Mine," featured in her hit musical, "Waitress." I watched this live on Broadway with my daughter. Both of us were in tears. My daughter, for her experiences up to the age of 20-something, and mine from my experiences up to the age of 40-something. What a challenging world we navigate for ourselves as women. Typically, we do this with children in tow. While none of us may feel entirely comfortable admitting we would consider starting over, many of us long for the girl we once knew.

Let's state the obvious: women get a raw deal when they step outside those old-fashioned gender roles.[28] Working outside the home is great but throw in raising kids and suddenly it's a whole circus. My research participants (all women) told me how childcare duties had torpedoed their career goals. From juggling school runs to general childcare duties, it's a never-ending tug-of-war. They want their kids safe and thriving, which usually means they're the ones making sacrifices at work. And guess what? When the kids get sick, who's always on call? Mom, of course. Not once has my spouse or co-parent stepped up

when someone comes down with the sniffles, and while I bet I'm not alone in that saga, I hope I'm wrong.

Personal life kicks in, too. Separate from your significant other, for instance, and bam—all of a sudden, you're wrangling everything solo. Many women, depending on their support network, end up passing on work opportunities just to hold down the fort. Even worse is the injustice of having to build a career from ground zero that supports everyone else when you've passed on work opportunity after work opportunity for "the good of the family."

One study participant told me she and her husband had separated after their last move, which led to her managing everything on her own. This Wonder Woman was still shouldering most of the childcare load, even picking up extra slack for her soon-to-be-ex to allow him "to relax and unwind." Divorce, especially after pouring 20 years into supporting someone else, can be devastating, to say the least. Women often see their living standards drop 30% post-divorce, while men tend to see a 10% increase.[29] It's a never-ending cycle of giving, with little-to-none being given back.

Even as women identified the weight of those traditional roles and responsibilities, they were torn about shaking them off. Some said they found joy in childcare duties but occasionally felt like they were drowning and overwhelmed. Remember, two truths can coexist. When asked what they'd offload to ease their stress and focus on work, several of the women from my study teared up at the thought of outsourcing childcare responsibilities. The guilt runs deep—no one wants to outsource parenting moments. One participant shared, "(Preparing breakfast for) my daughter is a barrier, (but also) a really cherished part of my day. It's part of the reason I look for a company with flexibility."

It's no surprise she treasures those morning moments. But let's flip that pancake: it means waking up an hour early and cooking up a storm before diving into a full workday. Trust me, brewing a cup of tea and flipping pancakes are night and day in terms of increasing stress levels and challenging your ability to mentally prepare for the

workday. And let me set the record straight: making breakfast isn't stressful–heck, I could do it blindfolded. Yes, I added that disclaimer because I don't want to be judged as a bad mom or wife. The guilt is heavy, ladies. It's insane what women juggle in their daily lives, am I right or am I right?

Let's be real here–even when women push through the guilt and focus on their careers, they still feel the need to add disclaimers, like I just did. That's why I got so excited when a working mother from my study told me she was owning her career without apology. Yet, seemingly just as quickly, she retracted the statement, feeling guilty for taking care of her job responsibilities. She ended up sharing that upon reflection, her work was not as important as caring for her children, as if she couldn't care about more than one part of her life at the same time, as if she felt obligated to quantify how much she cared about one over the other.

Now, let's talk about the elephant in the room–the COVID-19 pandemic (a brief aside: COVID was real, it was tragic, and healthcare workers are absolute heroes–end of story). It shook things up big time for women who had to make tough calls about returning to the office when schools and daycares reopened. Fear of COVID and the risk it posed to their kids was a huge factor. Some women chose not to stay in a role when the office reopened and working from home was no longer an option. In fact, half of women said they'd take a pay cut to keep working remotely.[30]

I'm not about to suggest you flat-out refuse to go back to the office. You probably need that job, and refusing might mean risking your paycheck. I'm definitely not telling you to ditch all your childcare responsibilities. After all, caring for children is rewarding (and at times, hair-pulling-level frustrating). What I will say is this: set some boundaries. Define when work ends and family time begins. It's not just good for you, it's helping your kids become loving, respectful adults. Boundaries teach respect and give you

time to recharge and think straight. It's a win-win. And please, resist the urge to be a superparent. Think about it—most superheroes had messed-up relationships. Superman ditched Lois Lane whenever duty called. Spiderman was always zipping around, barely present. And Batman? Well, do I really even need to comment?

Heroes risk everything for others, but it's not sustainable. Taking care of yourself isn't selfish—it's necessary. While you're busy setting those boundaries and practicing self-care, your children might not always be angels, but no one's kids are. Let's stop judging moms by how perfectly their kids look or act. We need to support each other, not tear each other down.

Repeat after me: "I won't shame moms who hire babysitters. I won't question where a mom's kid is just to make her feel guilty. I won't roll my eyes if a mom steps away from a Zoom meeting to care for her child. I won't deny good opportunities to moms because I assume they're too busy. I won't judge a mom if her child isn't spotless, or her house isn't pristine. It's not my place to diminish someone else to boost myself. I will *call* out those who unfairly judge women and I will promote self-reflection. Women set their own boundaries—no permission needed."

Your brief (but impactful) to-do list:

1. Reflect on your biases when you see women out and about. Do you silently judge? Do you wonder where their kids are? It's time to check yourself and address any bias head-on.
2. Fellow parents, it's ok to enjoy life outside the constant care of your kids. Maybe they leave the house with mismatched socks or a ketchup stain on their shirt—big deal, go out and enjoy yourselves anyway!

3. When you witness the juggling act of motherhood, step up. Hold the door open, shoot a supportive smile, and build a network of solidarity.
4. Attend support groups, share your stories, and unpack that mental load together.

Eldercare:
A Wrinkle in the Workforce

Many of us are afraid to change what has become comfortable. We have established lives, routines, and comfort within the confines of what our life experience has developed. As we age, time makes some of us wiser and braver. This is illustrated in the song "Landslide" by Fleetwood Mac. This chapter is about the care that we need as we age, and the responsibility that is required from our families.

A lot of us are also juggling the care of an aging parent. Trust me, I get it: having your mom move in and share your space, time, and privacy can stir up a cocktail of emotions. Hey Mom, I know you're reading this–thank you for keeping the floors clean, the dishes done, and the pantry full of snacks. It might seem trivial but having that kind of support makes a huge difference. Now I can skip the dishwashing between meetings, which is a lifesaver. The work-life wobble was definitely wobblier before my mother came to live with us.

But let's get real–this chapter isn't for those we're taking care of; it's for us, the caregivers. It's all about giving you the tools and language to set the boundaries you need. Yes, you heard me right:

you have the right to say no and prioritize your own well-being. Shocking, I know. Caring for an aging family member isn't just emotional; it's logistical chaos, too. From taking them to medical appointments to trying to maintain a social life and squeezing in date nights, it's a lot. One woman from my study shared, "My biggest responsibility is managing my dad's life. It's hard to say because I'm honored to do it, and yet, it's a huge responsibility."

Many of us genuinely want to care for our parents. It's a beautiful experience, getting to return the favor for, well, giving us life, but it's also an enormous responsibility. After all, we're talking about managing another adult's life. My research participants said they struggle to balance caring for another grown individual while also being on their A-game at work. Forget stretch assignments—at this point you're lucky just to show up on time. From one spread-thin woman to another, the struggle is real.

One woman from my study mentioned that the extra responsibilities of caring for her mom added so much stress to her day that her professional focus took a hit. Constantly needing to drop everything for caregiving duties can seriously disrupt your workday, leading to monumental stress and frustration. But caregiving isn't just emotionally taxing (shoutout to my wonderful daughter who, as a nursing assistant, is already practicing caring for me in my old age). Taking care of another adult can also be financially draining. So many women turn down work opportunities or big projects as they face the pressures of caring for a family member. This means missing out on those lucrative gigs and career-boosting assignments.[20] Don't even get me started on the nightmare of understanding and selecting the best care providers, navigating health insurance, and handling deductibles and copays. Becoming a pseudo-expert on complex healthcare stuff can baffle even the savviest of caretakers. It's a mess.

When I dug into my study data, I found BIPOC women were handling eldercare way more often than their white

counterparts–90% compared to less than 30%. This highlighted the additional stressors BIPOC women face, especially since these communities often have lower overall earnings and higher costs of living.[31]

Women in my study often found themselves stuck in unfulfilling jobs to keep their families afloat. I imagine men can relate to feeling trapped in jobs for similar reasons. Some of the women wanted to further their education so they were better equipped to climb the corporate ladder, but they didn't have the time or money because those resources were funneled into supporting an aging parent. It's clear the caregiver burden isn't just about childcare; it's firmly rooted in eldercare too. At some point, we deserve to receive the care we're always expected to give.

So, how do you cope? I'm glad you asked. Here are some tips that will allow you to carve out space for yourself while providing compassionate care for your elderly family member:

Set boundaries. This one is tough because you might face resistance from the person you're caring for and feel guilty yourself. Set those boundaries anyway. You'll probably need to repeat and re-explain them, especially if your family member is dealing with dementia. Stay patient when they peek into your bedroom or stop by unannounced (I know, easier said than done). It's okay to say, "This area is our space for privacy. Could you let us know when you're coming, or ask us to bring you what you need from here? Our privacy and space are important." Or say, "We need to spend the bulk of the weekend reconnecting and recharging. We'd love to share brunch with you on Sunday." Say it with me: "I have the right to set boundaries." I have to remind myself of that every day.

You may also find yourself setting boundaries about something more trivial than privacy, like requesting that your aging family member uses plastic cups instead of glass, so if they are dropped, you aren't struggling to find sharp pieces all the way from the refrigerator to the living room couch. They might push back with

something like, "But I've always used glass containers." If it's a safety concern, you'll have to draw those boundaries.

Encourage independence. Make sure your elderly family member can still do the things they enjoy. Encourage them to use Uber or Lyft, or even a driver from the neighborhood you can trust. You don't have to be the sole transportation provider. If they need physical therapy (usually covered by insurance), find a center with a vibrant social component to their treatment. You may also consider checking your local extension office for volunteer opportunities they might like.

Leverage help. If you have college-age neighbors home for the summer (only safe drivers, of course), see if they can do short transportation runs. Talk to their parents and arrange a flat or monthly fee for them to accompany your loved one to the grocery store, shopping center, or community center.

Acknowledge their feelings. As your elderly family member realizes they're losing autonomy, they might blame you and rail against their confinement and limitations. It's tough when the dynamic shifts from caregiver to caretaker. Listen and reassure them you are there for support. But remember, you also have the right to set boundaries.

Prioritize mental health. Ensure your loved one has access to a therapist. Watch for signs of depression and encourage them to get medical support if needed. If they become more combative or agitated, reach out to their medical provider. They'll feel better, and so will you.

Some reminders:

1. Set clear boundaries with the elder family members in your care.
2. Enlist a counselor for the family member in your care, and one for you, too, to help you navigate your feelings.

3. Find support groups and activities outside the home for your elderly family member to give yourself breaks (and while you're at it, find some fun stuff for you to do, too!).
4. Let yourself off the hook and be selfish every once in a while–you deserve it.
5. Allow other family members to step up and help. You shouldn't have to do this alone.

The Work-School Squeeze

There are few female rappers as heavy as MC Lyte. In fact, she clearly tells us the metaphor of her lyteness is really a reflection of her heaviness, in her song "Lyte as A Rock". When this song came out, it hit hard. When I crossed the stage to receive my fourth degree—the one that earns me the title of doctor—I couldn't help but wonder if they grasped the heaviness they had released into the world...

Almost every participant in my study shared that balancing education and work responsibilities was a challenge. Some tried to juggle it all by extending the timeline to finish their education programs, but taking longer just hikes up tuition costs (and women are already paid less—thank you, wage gap). But hold on, there's some good news: Women are outpacing men in college enrollment *and* college completion.[32]

Statistically, women take longer to complete their degrees than men, often because they are forced to balance their studies with a full-time job and familial obligations. For those who take longer to complete their education, it's a double-edged sword. The women from my study reported a negative impact on their careers because they had to manage a full-time job alongside their extended educational studies.[20] This also curtailed their ability to take on

stretch assignments and excel at work. So, we have to take longer to get a degree, which costs more and hurts our careers longer. So why bother? Why not just skip the stress, effort, and financial burden? Let's discuss…

Education is important. It quantifies your knowledge, unlocks new opportunities, and strengthens your career prospects. Not to mention, the lack of a degree can certainly be used against you, breeding a slew of additional workplace challenges, especially when you're from a marginalized group like women (and especially BIPOC women). One participant in my study said both her and her husband's families regularly questioned her about her lack of advanced education. "I've been questioned because I hadn't finished my undergraduate degree and was told I wasn't educated enough to have an opinion," she told me. Seriously? She's educated enough to be the primary caretaker, the first educator of her children, and a private chef for her entire family, but her lack of degree supposedly voids her efforts and expertise. Mind boggling.

Eventually, I grew tired of everyone at work flashing around their bachelor's degrees while I was rocking practical experience. I was tired of being asked where I went to school when I knew they weren't interested in which high school I graduated from. Take it from me, lack of advanced education can evoke feelings of embarrassment, disappointment, isolation, and a lack of respect (not that any of these feelings are representative of the truth: work experience can be far more valuable than a degree).

The final straw came when I realized a number of jobs I was interested in wouldn't even interview me without a degree. So, from 2017 to 2023, I decided to pursue the full-time school-full-time work juggling act. It was stressful, but I had an advantage: my daughter was a full-fledged adult with a job, benefits, and a steady income. She cooked her own meals and sometimes mine, too. I had social support and wasn't her caretaker anymore. After

being a single parent (or feeling that way) since 1995, I could finally focus on myself. It still amazes me that with the right conditions (grown children and no unsupportive partner to discourage me), I was able to earn four degrees in just six years. The crazy part is that I landed a manager position just months after receiving my bachelor's degree (degree #1). I was the same me with the same skills, but now sporting a fancy diploma and a 57% pay bump. That's right, my salary more than doubled! That's the education effect–your salary can increase exponentially with the right degree (don't panic–you don't necessarily need four degrees to make that happen). (Not so) funny how that works, right?

Women are in a constant cycle of making compromises they shouldn't. The decision to pass on a promotion breeds anxiety (and often a sense of guilt) as women reconcile the truth that such opportunities may not come their way again. The internal balancing act women experience– doing what's right for their family versus prioritizing their own education–exacts a high emotional price. The decision to invest time and money into education is challenging, to say the least. This emotional turmoil is compounded when companies don't offer the social support systems that are pivotal for promoting female advancement in the workplace.[20] As a result, many women stay in positions that allow them to experience the best available work-life balance with space to return to school, even when that means stifling their career aspirations, making less money, and stunting their promotion track.

When the corporate landscape becomes too harsh and the harassment too pronounced to remain engaged, some women go so far as to vacate their roles entirely and gamble with their future by establishing their own small businesses. This creates additional financial stress and often places education on the backburner. It may also widen the wage, healthcare, and PTO gaps. Business ownership is not for the faint of heart, and it presents extra challenges to

women with children. Trust me, I know. I did it and vowed to never do it again.

So, here's my take: if you're serious about getting that degree, do it strategically. I'm a big fan of online schools, like my alma mater, Western Governors University. They offer a competency-based model where you control the pace of your education and can leverage your real-world experience. It's not a walk in the park–it takes dedication and focus–but at least for most courses you're not tied down by weekly meetings. Then there's National University, another great option (and my second alma mater–ok, maybe I'm a little biased). They lay out your entire 8-week course upfront, giving you clarity and the chance to push ahead when you can. No more wasting time on campus parking or battling distractions in class. It's a game-changer for getting that degree on your terms.

Both schools are the real deal–fully accredited, certified, and supportive, with plenty of financial aid options. They graduate diverse students at higher rates than traditional universities (excluding HBCUs–they still come through for us), and they won't drain your bank account like those big-name schools. Online universities save you precious time and money, and I encourage you to drop the notion of a "prestigious school" and opt for a more affordable education. In my strong opinion, there is no need for hundreds of thousands of dollars in student loans or commuting expenses.

Some final words of advice: If you're considering school, just go for it–it's never too late to go back. Time's going to fly, and let's face it, nothing worth having comes easily. But having that degree? It'll definitely make your life easier. Don't let anyone talk down to people who didn't go the "traditional" education route. Shut that noise down right then and there. When it comes to picking a school, keep it simple and affordable. Online, on-site–it doesn't matter. What matters is getting that degree and making it work for you.

Remember:

1. Go back to school if you want to. Yes, it will be hard, but having a degree makes your life easier. It's never too late, and it is always worthwhile.
2. Do not allow others to put down people without a "traditional education" (whatever that means) and set the record straight so they're a little less ignorant the next time they decide to broach the topic.
3. Find the least expensive *accredited* school that provides the flexibility you need to succeed. Online is great and in-person is great. It's about getting the degree, *not* where you get it from.

If you've decided to go back to school (congratulations!):

1. Make a list of the knowledge and skills you've noticed other successful people around you have. Which ones are you missing? Which ones would you like to focus on?
2. Make a list of topics and interests related to your current or future career.
3. Research online schools and compare costs and degree completion times (remember to make sure they are *accredited*).
4. Discuss your intention to return to school with your family or social support network.

Approval Not Necessary

Katy Perry "Roared," and I wept. Funny how an upbeat song can bring back memories from lower times. Biting your tongue while standing in the fire is a special type of torture. To those of you who have been knocked down and then got back up, rising from the dust, I applaud you. Get ready, because we're about to shake the ground together. Welcome to the chapter on ambition.

I need a deep breath for this one.

Your drive is not dependent on outside acceptance, and it is not open for debate. Pause and truly, deeply consider that fact. *Your drive is not dependent on outside acceptance.*

There will always be someone saying, "You push too much." "Why are you everywhere?" "Why is it always you?" "Why are you in the front row?" I don't get why people are so bothered with other people's success. It boggles my mind. These are the folks who, when they look deep inside, find a void and try to fill it by managing others' fullness.

I've been told countless times to "just slow down." And I always think, "This is just the warm-up. I'm nowhere near full speed." And also, why? Why do I have to slow down to match your speed? I'm not asking you to keep up and I'm not judging your pace, so why are you so concerned with mine?

I've also been told to be "a bit more likable." My internal voice (my very, very quiet voice) says, "Could you please just focus on the quantifiable success I just delivered?" The whole notion of likeability is flawed. Whether you like me or not depends on so many factors, some of which I can control, some of which I can't, and most of which I'm not going to bother to. Other factors include someone's unrecognized bias, and that's not worth a fraction of a second of my time. No matter what I do, I may never be more "likable" to you. Big. Whoop. Especially for women, being ambitious often results in being disliked. We all know when we're not the favorite. But tell me, since when is being a favorite directly linked to organizational profits? I've yet to find science linking the two.

Favorites are set up for success. They're given perfect messes with all the tools, guidance, and support to create a masterpiece. Then, their mistakes are covered up or minimized, and any incoming fire is blocked. The success of favorites is the least impressive thing ever. They have built-in likeability that's unearned and not based on performance. So, when you get the "be more likable" comment, redirect the conversation. Calmly and clearly restate your incredible, quantifiable results. This might make them uncomfortable. Relish in their discomfort as they realize the flawed, biased feedback they tried to pass off as fact. But be cautious, because uncomfortable people can react unpredictably. This is why you (say it with me now) *need a mentor.*

I see success like sunshine. We can both walk outside and feel the sun. One person doesn't get all the sunshine; there's plenty to go around. Success is the same. My success doesn't limit yours, and yours doesn't limit mine. There's an abundance of success to go around, especially if we all share it equitably. Just like sunshine—we all deserve it and have access to it. The more people who think of success this way, the better off we'll all be.

Every year of my professional life, someone has commented on my attitude instead of my accomplishments. If you're showing up as

your best self for the circumstances you are in, your accomplishments should outweigh your attitude. Now, I'm not saying I didn't earn some of the attitude feedback. I *am* suggesting that women receive more attitude feedback than our male colleagues, and that there are more important things to focus on than my attitude. This kind of sexist feedback does, however, go hand-in-hand with the other "helpful" advice I've received while blazing my ambitious trail. This reminds me of one piece of "advice" in particular: "Your face said it all. Could you fix that?"

If only I had a dollar for every time a well-meaning manager (yes, even women) wanted me to fix my face. I would have preferred hearing "Smile more, honey" from construction workers I pass on the street. Why can't I show a look of utter confusion when people do utterly confusing things? What's the stoic face, or should I say facade, I'm supposed to wear while staying "authentic?" What type of performance am I expected to play when someone says something utterly ridiculous? I had no idea how to play this game of neutral contempt. And that's one of the reasons I wrote this book.

Here's the truth: it's perfectly fine (and frankly, encouraged) for you to redirect the conversation to something more quantifiable when someone tells you to "fix your face." How you do it, though, is key. I've been told to fix my face every year of my career, and it was never the right advice (okay, maybe sometimes it was). Still, it's appropriate to say, "But can we talk about the product I delivered?" If you think you could benefit from practicing this kind of redirection, get yourself a mentor.

In my research, over 95% of the women I interviewed were told to be both more *and* less assertive. Take a beat and let that sink in. Honestly, if I weren't doing 38% more work post-COVID, I might have had time to ask men if they've faced the same conflicting messages, but I'm going to go out on a limb and guess they haven't heard this as much as women have. How are women ever supposed

to get to the top if we're constantly getting mixed messages on how to climb? It seems rooted in the belief that women should bend and mold to fit a certain description. The expectations on us are intense. Balancing what's perceived as feminine or non-assertive with what's truly valued in the workplace–confidence and assertiveness–is nearly impossible. When 95% of women report this experience, it's not just a one-off thing.[20] One study participant shared:

"The first time it happened, I was probably three years into my professional career, and an executive director told me, like point blank, 'You're too ambitious.'"

How is that even possible? How does one even begin to decode that cryptic message? Why was the comment ever made, and was it even worth considering? I'm confident I'm not alone in giving these mixed messages too much headspace. So, here's your freedom from that dreaded instant replay in your mind. Toss it out! It's bad advice (not to mention poorly delivered) and you have every right to discard it.

Your ambition is not up for discussion, and what other people think about your ambition is none of your business (say it again for the people in the back!). Why? Because companies are searching for solutions. In the current environment, they actually need you to be fearless, ambitious, and to push hard to move the ball forward. If you're focused on what others think of you instead of innovating, you can't get there. You can't be your fully creative self if you're worried about being "too much" or "too little" for someone else. Focus on bringing your full brilliance to the workplace and ignore things that are none of your business.

Opinions wielded by the mediocre, territorial, or threatened are none of your business. Those folks aren't your tribe. They'll never get it, and they're not nearly as brilliant as you. No matter what their title says, if they're tearing you down, they're not your people and they're not invested in your growth, so steer clear. Don't rent

them headspace, and when you consider their words, take a step back and realize how absolutely absurd they sound. Case in point:

"I was told to stop asking questions, and that by asking questions I wasn't demonstrating leadership abilities."[20]

Have you ever heard anything more ridiculous? I've been told the same thing. One time, my questions apparently disturbed the employee group. My unfiltered response was, "You mean it made them think?" Yep, that was before I had a mentor who would have helped me navigate this scenario with a bit more finesse. But I wasn't wrong. Companies claim they want the brilliant questions–until they actually get them.

One more important note: sharing your ambition with everyone isn't always the smartest move. Sometimes you share your dreams with the wrong person, and they go out and buy boulders to throw in your path. They plan five steps ahead to block every route you could possibly take. Those are the worst. Learn to spot the differences between friends and foes. It's crucial for navigating the corporate landscape. But remember, just because you run into a few foes doesn't mean you should let go of your ambition.

Doubling down one more time: Your ambition is not up for discussion. What other people think of you is none of your business. Refocus others, and yourself, on your accomplishments, not your attitude.

Let's get ambitious!

- Review your list of skills you want to develop from previous chapter reflections.
- During team, segment, and global meetings listen for areas of P0 or top priority for the business.
- Send a message after the meeting to the individual who discussed the priority and share your interest

and curiosity about the ways those priorities are being tackled. Volunteer your time to support the project.

- Make a list of departments you want to collaborate with and schedule meetings with individuals in those departments.
- Stay curious, ask questions, and learn about what others are doing in the departments you've identified. Listen for projects that could develop the skills on your list.
- Strategize ways to talk to your boss about pursuing opportunities with different departments to develop your skills. Use your mentor to create a game plan.
- Keep pushing forward and let your brilliance shine!

Embracing What Elevates

The Swiftie in me resurfaces in a song that so clearly captures my decades of frustration within the corporate landscape. Would things be different if I were "The Man"? What would it feel like to speak and actually be believed? To be seen as fearless instead of hysterical? I imagine I wouldn't need to sprint, and that it wouldn't take as long to reach the same goals. For now, until the playing field is leveled, join me in this chapter on seizing our opportunities.

You have the absolute right to say YES to the things that serve you. Period. End of story. Give yourself permission to say yes. And guess what? That also means you have the right to say NO. How does saying yes or no play out in real life? Let's break it down.

Companies are getting leaner, constantly restructuring, whether proactively or reactively. Economies ebb and flow, creating ripples that affect us all. When companies restructure, the workload doesn't shrink–it just gets dumped on fewer shoulders. This hits individual contributors the hardest, and managers struggle to balance the load. This on top of us all doing more with less. Remember that 38% drop in work-life balance we talked about earlier? Well, given the current corporate landscape, you may find yourself having a discussion with your manager that sounds something like this:

"We have this great new project, and given your skills and abilities, I think you'd be perfect for it. Could you take on this additional assignment and the work that comes with it?"

Your first thought might be, "This is my chance to shine." Many of us have been waiting years for our big break, watching others land top assignments and the visibility that comes with them. Those of us in marginalized groups have been waiting on the sidelines—sometimes it feels like lurking—for just a sliver of opportunity to showcase our brilliance.

Next time you are faced with this kind of situation, the first thing I want you to think about is *yourself*. I hope you're able to say to yourself, "I prepped for this scenario with my mentor, and I'm ready!" If you already have a game plan, feel free to skip this chapter—but I bet you'll want to keep reading. Let's just acknowledge the obvious. If you've been asked to take on additional work assignments, you probably need to agree, and your future career trajectory might depend on your enthusiastic yes. So, deliver that yes with gusto and jump straight into negotiation.

Negotiation? Are we talking about asking for more money? Nope, that's not it. I'm talking about a crucial negotiating concept I learned from Jeetu Mahtani, a senior corporate executive. Jeetu is a dynamic leader in the field of technology, known for his thoughtful approach and decision-making. He is also recognized as a shrewd negotiator. In the predominantly white technology leadership space, Jeetu stands out and gives back to the BIPOC community. He taught me this: negotiate your rewards before you complete the work. I'll say it again: negotiate before you deliver the results. You can't negotiate your reward after the work is already done.

What and how should you be negotiating? Focus on two key areas from the get-go. Ask yourself two questions: "What type of exposure will I have when I complete this assignment?" and "Do I get to work cross-functionally?" Clarify these points before you accept the stretch assignment.

Lori Nishiura Mackenzie from the Stanford VMware Women's Leadership Innovation Lab spoke at an event I moderated. She discussed negotiating around "stretch assignments," defining the goal as gaining visibility and exposure, which can be more valuable than immediate compensation. Visibility and exposure can lead to promotions and, ultimately, more money. Lori emphasized that there's always something of value to extract from a stretch assignment, so always negotiate–even if money isn't on the table. Your negotiation might sound something like this:

"I would love to take on this new assignment. It sounds fantastic! When I successfully complete it, do I get to present to your skip level?" (That's not just your manager's manager, but a level above them–real visibility!).

If the answer is no, follow up with, "How can we make that happen?" Listen carefully to what they say and what they don't say. Clarify the reasons your manager has for their positive or negative response. Are they protecting you from a hostile environment on the other side of the project, maybe even hostilities you are unaware of? Or are they claiming credit or buffering your accomplishment for their personal gain? Either way, you'll gain insight into whether your manager is committed to your growth and visibility. No matter their response, even though you'd prefer their support, *don't stop there*! You have another crucial negotiation question to ask: "Do I get to work cross-functionally with other teams?"

This is critical for expanding your reach and visibility outside your immediate team, which will play a key part in your career advancement. If the answer is no, follow up with, "One of my goals this year is to expand my impact beyond our team. Could we identify some additional teams that might benefit from my work on this assignment and plan a path to collaborate with them before we get started?"

When you take on extra work, it must also serve your growth and development. It's a two-way street. Ask for access to senior

leadership. Ask to present the results of your work. Ask for credit where it's due. Clarify with your manager what will be different when you successfully complete the additional work. Ensure that successfully completing the stretch assignment has a positive impact on your career and visibility. You have every right to ask for that.

Do you currently ask for access when you get that extra workload? Do you currently think to yourself, "This is great!" and strategize to maximize the opportunity for yourself and your team? There's nothing wrong with this. Reposition your thinking and seize the opportunity. Make sure you're seen and recognized across the organization as a valuable asset.

Of course, it might not always go as planned, especially if you are marginalized and working in a women-averse environment. You might face challenges like retracted resources, leadership changes, or project reprioritization. These things happen. They're just part of the corporate landscape. But remember, you still have the right– and the responsibility–to negotiate the best possible outcome before taking on extra work. Practice these scenarios with your mentor so you're prepared. Learn how to navigate stretch assignments to ensure they benefit you, too. That means never, ever accept additional work without thinking about yourself. You're putting in extra effort without extra pay. Personal investments like this are common, but you deserve to carve out additional rewards for your hard work (especially when your labor costs the company little-to-nothing).

What if, despite your best efforts, you know you won't get any additional benefits? Maybe you have a manager who won't support you or champion your visibility and career advancement. What then? Since the workplace isn't always (ahem, ever) completely fair and equitable, you need to be ready to turn down stretch assignments that don't benefit you. We need to normalize saying no without friction, guilt, or apologies. That's right, if you're not going to get access to senior leadership, cross-functional exposure, or personal benefits, say no. What would that even sound like? It may only be a

two-letter word, but that doesn't mean it's an easy one. Your mentor can help with this–here's a clear sound bite to consider:

"I appreciate you thinking of me and my skills for this opportunity. While it would be exciting to participate, this year I am laser-focused on developing my XYZ skills. I want to ensure I excel at my main job while also looking for opportunities to expand into XYZ. I realize it may take a bit to find the right learning opportunities, but I'm very aware of my bandwidth and capacity. Based on that, I hope you'll support my passing on this opportunity and partner with me to create more access to develop that XYZ skillset."

This isn't an easy or psychologically safe message to deliver, so practice saying it out loud *a lot* before you need to say it. You have the right to say no to things that don't serve you, especially when they benefit others more than you and disrupt your work-life balance.

1. Make a list of what skills you want to develop within the next year and why you want to develop them; share that list with your manager and ask for their support.
2. Make a list of what skills you do not want to prioritize for the next year and share those with your manager, too.
3. Work with your mentor to practice what you'll say when you decline opportunities that don't align with your goals.
4. Embrace your right to say yes and no, and make sure you negotiate for the credit and access you deserve.

Meetings, Mayhem, and Marginalization

"Praying," by Kesha, is all the frustration of the current landscape in a succinct 3-minute, 47-second package. Those of us in marginalized communities walk through the fire daily. We expect Hell to rain down on us, and we fight with ferocity to hold on to every bit of progress we make. I think of the lies people have told about me and the truths I've kept hidden. I hope those who've wronged me are reflecting on their actions, if not actively trying to make amends. Buckle up, because this chapter and the ones that follow are tough.

Alright, tribe, let's get real for a minute. This chapter is brief but heavy, and I hate to bring the mood down, but we've got some truths to discuss. Many women in my study shared that they passed on promotions because of conflicts with their traditional responsibilities. They felt guilty about taking on bigger roles that would cut into their parenting time. They struggled with whether they had the right to carve out time for their own education. Some women even wondered if they should stop saying "no" or "yes" and just exit the corporate world altogether. Even when we make it to the party, the cost of staying is high.

When I talked to the women in my study, 100% wanted to take on new projects or roles. But over 70% of them passed on these opportunities to avoid further strain on their personal time and relationships.[20] These numbers show the struggle women face in balancing personal and professional success. The compromises we have to make are staggering. What's the right amount to give up personally for professional success? And vice-versa? Women are constantly balancing the challenges they crave in the workplace, the excitement of a new assignment, with their traditionally assigned responsibilities. This has real-world consequences and impacts career trajectories. Consider this study participant's experience:

"I took my current role today as opposed to a probably slightly more exciting position...with my husband starting medical school and three little ones that was not going to be a fit."

Ah, the back-of-the-mind question every woman asks herself: "What might have been?" I wonder, as does the working mother I interviewed, what would have happened if she had taken that more exciting position? Who would she be now, mentally, career-wise, financially, and personally, if she had the freedom–freedom that many men enjoy by comparison–to seize opportunities?

Get ready, because the next chapters dive into the extra hurdles and sacrifices women make to navigate the corporate world. Balancing personal and traditionally assigned responsibilities while climbing the career ladder is a tightrope act that creates unique vulnerabilities for women. With challenges like marriage, pregnancy, childcare, elder care, sexual harassment, the pursuit of education, and dealing with unsupportive leaders, it's a wonder we have any women left in the workforce at all. But guess what? Our resilience, savvy, determination, and excellence shine through every time we clock in.

For those of you who aren't women, buckle up. I'm about to walk you through the gauntlet we face every day. And for my fellow

women, as you read and find solidarity in these experiences, let's push for real change in workplace dynamics together.

Now, let's get personal:

- Think about the opportunities you've passed up. Reflect on why you passed up those opportunities and how it felt to let them slip through your fingers.
- Would you make the same choice now?

Smashing Stereotypes

This book would be incomplete without acknowledging the inspirational women who busted out of the kitchen and made waves in the world. Remember when Annie Lennox and the Eurythmics boldly declared "Sisters Are Doin' It for Themselves"? It was unapologetic and downright shocking at the time. Just in case I haven't made it clear, we are doing this—whether you're with us or not. This chapter is a thank-you to the strong female leaders I've had the privilege of learning from and a wake-up call to those still holding back marginalized communities. Consider yourselves on notice.

I would like to start this chapter by making it very clear that Maria from "The Sound of Music" didn't have a "problem," and there was nothing about her that needed to be "solved." The fact that I sang that song with such whimsy as a child (and as an adult) illustrates the programming that happens from such an early age. When I reflect on what my female leaders have endured, and their constant battle to justify their position and authority in the corporate landscape, it seems I'm far from the only one to have been "programmed."

In the workplace and beyond, it's common to see people trying to fix strong, assertive women. "How can we calm her down?" "Why does she push so hard?" "Women can't work together." It all

intersects. Conversations about not wanting to work for a female leader are commonplace, yet resistance to working for a male boss would more than likely result in unemployment. I suggest we don't see the Marias of the word as a problem needing to be solved, but that we work together to embolden more Marias–more strong, capable, and opinionated women.

I can't stress enough the importance of a manager's role in elevating and creating a sense of belonging for their marginalized employees–particularly for women. Sure, I've talked about the impact of white male mentors and allies, but I've also had some phenomenal female leaders who deserve a standing ovation. These women have taught me invaluable lessons and coached me through difficult situations. They've paved the way and shown grace when I stumbled on my climb up the corporate ladder. If you're lucky, you'll meet a female leader who will teach you the ropes and help you thrive. One such leader for me was Michele Brady, or as I have her saved in my phone, "Michele BADASS Brady." Michele taught me how to negotiate my salary, boosting it by $40k with her bold advice. Her mantra? "Ask for 20% more at a minimum, and don't settle until you get it." Her unapologetic approach was both shocking and inspiring, and I leaned into her guidance with eagerness to learn more.

Another powerhouse woman who influenced me later in my career is Sacha Dekker. Sacha is tough, and apparently not everyone's cup of tea (which baffles me and also makes her #tribe). She's a woman with strong opinions, which doesn't always get a warm reception. She's direct–a trait that corporate America (and beyond) is still grappling with when it comes from a woman. But her boldness allowed me to flourish, grow, and challenge my assumptions. Sacha told me I was wrong…All. The. Time. She did it both publicly and privately, because she valued my opinion and created space for me to share it. She normalized constructive feedback and delivered it when it mattered most. While this rubbed some people the wrong

way (as gutsy women often do), I found it brilliant. She elevated my work and gave me opportunities to present at the highest levels of the company. She appreciated my moxie, my talent, and well, me.

Now, imagine you received the above description of yourself. Imagine knowing there's a publication that says, "you are not everyone's cup of tea," and your response is, "I totally support what you're writing, and you have the right to describe me as you experienced me." Now, that's what I call support. That's the kind of self-sacrifice and perspective an incredible leader provides. They say things like, "I support you," "go conquer the world," "don't change a thing about who you are or what you say," and "be you, and know I've got your back." That's exactly how Sacha responded, and what a gift that was.

I once heard Bozoma Saint John, Netflix's former chief marketing officer, discuss being in a room filled with people who were mostly men, and all white. She suggested that when you finally get a seat at the table, don't just pull up a chair–make some room, put your elbows on the table. To me, great leaders give you access to the table, create space for themselves, and then pull up a chair for someone else. That's what the incredible female leaders in my life have done. They showed me where the building was, guided me to the room, and gave me a seat at the table, allowing me to pull up another chair for a deserving colleague.

Pause and re-read the descriptions of the female leaders mentioned above. Now, imagine I was talking about male leaders. Do the descriptions hit differently? Tough, opinionated, direct, bold, audacious, unapologetic–sounds like you've hit the jackpot, right? But when these terms describe female leaders, it's a whole different story. Don't believe me? Ask Hillary Clinton how that went for her. Unconscious gender bias is real and has real-world implications for women in leadership.[33]

I regret to say that the support these women leaders provided often came at a personal cost. Sometimes, their support even

damaged their own careers. Young men, considered progressive, are unlikely to endorse female leaders even though employees prefer female leaders.[34] Women in leadership are judged more harshly and with more bias than their male counterparts.[35]

Consider this scenario: I had a new female manager, and I was beyond excited. At our first team meeting, she talked about power-posing. I thought, "Ok, not my thing, but I'll give her a chance." Then, during our first one-on-one, she asked me to walk her through the existing sales process, step by step, like a role play. No manager had ever asked me that before. She literally wanted me to pitch the product our company was selling. It was our first one-on-one meeting, and I had no script in front of me. Then, it got worse.

Typically, when you do a role play, the person you are running through the exercise with is about a four or five out of 10 in terms of difficulty. She wasn't just a little challenging; she was an eight out of ten in difficulty, and I felt myself starting to panic. It wasn't that I didn't know the information. In fact, I knew it extremely well and had been a top seller, directly involved in writing the sales script and modifying the sales process. But my new boss had a powerful presence, and I wanted to impress her.

I left that meeting thinking it was the worst one of my life, sure I'd be demoted and dismissed. I even spent time scrolling through job boards. But at our next team meeting, I found out she had been...impressed? Apparently, I had done what none of the other trainers had managed: run her through the entire sales process. It set us up for a terrific relationship based on mutual respect.

Despite being dynamic, direct, capable, credentialed, and experienced, the organization didn't appreciate her. Leadership continually marginalized her, and even worse, several team members began doing the same. Meetings where she wasn't present turned into gripe sessions about her. The nastiness was spearheaded by the interim manager, who had lost out on the role to my new manager. To make matters worse, the interim manager was a woman,

deliberately undermining another strong, female colleague out of what I can only assume was jealousy. Talk about disappointing. To make matters worse, I was the only one who stood up for her (a decision that I don't regret for a second but made me wildly unpopular amongst my teammates). Not another soul stuck their neck out to defend this wonderful leader, not even the many individuals she had promoted and supported. The pack mentality was real, and she was going down no matter what she did.

What made this manager of mine so phenomenal was her willingness to step aside and let her team lead. During a major sales process transformation, she allowed me to take center stage. She created space for me to present the content I'd worked so hard on, sitting down so I could stand up in front of the Director of Training, the VP of Sales for North America, and the CEO of the company. Can you picture your current leader taking a back seat, not saying a word, and letting you receive all the praise and recognition for your hard work? That's what true support looks like. That's the kind of leadership we should all aspire to–and demand.

Her reward for her exceptional and generous leadership style was being laid off with even less notice than I was given during COVID-19. The executives iced her out and marginalized her talent. Her collaborative and respectful approach was undermined and dismissed. The company made it clear there was only room for one successful female leader on the team, and she had abdicated her role.

Is it any wonder women share stories of not being supported by other female leaders? The fear of there being room for "only one of us" fuels this narrative of required competition. It's bizarre because there are plenty of men in the workplace, and they're rarely pitted against each other like this. So, to those of you who pit women against each other, we're onto you. We're done with the backstabbing, gossip, and takedowns. If you're going to speak ill of a woman at work, you'd better back it up with their actual

performance metrics. Otherwise, prepare to have your biases called out–very publicly. Enough is enough, and I'm confident that those who've read this far have had enough, too.

If you are a company leader–of any gender–and choose to badmouth a woman at work or at any work-related event, shame on you. If you do it out of personal bias and aren't in leadership, shame on you, too. It shows your true character, and frankly, you need to sit down and be silent–especially if you're enjoying the privilege of being a favorite. And if that last bit sounds specific and personal, good. That's because it is. It is disgusting when this happens, and I've been on the receiving end–more than once, I'm sure.

One final note on leadership: I encourage each of you to stop shopping for the perfect job and start shopping for a great manager. Even the best job turns sour with a terrible leader, while the worst job can leave you feeling valued and inspired with an incredibly supportive manager. Look for an experience that makes you feel better at the end of the day. You deserve that, and if you don't have it, you deserve to leave whatever doesn't serve you.

A few reminders:

1. When interviewing, shop for the manager, not the job.
2. Call out managers who are unfair, unsupportive, and who tear their employees down instead of empowering them.
3. Speak up when you see incredible leaders being marginalized or facing microaggressions.
4. Tell good leaders you appreciate them.

Unwanted Advances and Uncomfortable Glances

*As I sat at a Pink concert realizing the intended purpose of "Blow Me" and the added "One Last Kiss" to make the song palatable, I thought of all the people who deserve calling out for the sh*t days they have created for others. This chapter encapsulates the rage, anger, fear, shame, and disgust I have for sexual harassment. Do not enter this chapter unless you, too, have had quite enough of it.*

Time to get into it. Sexual harassment is insidious. It is not locker room talk or "boys being boys." Sexual harassment impacts countless women in the workplace who face a barrage of discouragement, marginalization, gender microaggressions, and plain-old sexism. Sexual harassment includes unwanted touches, comments, and at times forceful and painful encounters that are seldom answered with justice.

The contributions of women in the workplace are frequently marginalized, devalued, or outright dismissed.[36] Yet, despite these obstacles, we keep pushing toward leadership roles, even as we face male-dominated, women-averse corporate landscapes. Why? Because we're tough, resilient, and built to overcome. Or maybe

we're just too stubborn and driven to quit. Perhaps we feel called to make the path a bit easier for those who come after us.

The women in my study shared that they wanted to be treated equally and to earn promotions—without the daily sexual harassment and marginalization that still occurs in the corporate space and beyond. One participant ditched corporate America entirely and started her own business just to escape sexual harassment. "Sexual harassment in the workplace…was a big driver in wanting to have my own business and not have to deal with that or have to leave jobs because no one would do anything about what was happening in the environment," she told me.

Can you imagine giving up your entire career because the thought of another sexist comment or touch is just too much to endure? Now, try starting a business while healing from layers of trauma. As an entrepreneur myself, I can vouch for how challenging it is to launch a business, even on a good day. It's a treacherous journey, especially without the safety net of a steady paycheck. Sadly, many of us don't need to imagine it—we have lived it ourselves and are now forced to see our colleagues, children, and family members enduring similar harassment.

I climbed the corporate ladder during the days when women fetched the coffee, received slaps on the ass, and were called sweetie, honey, and sugar so many times you'd forget your own name. "Sleeping your way to the top'" wasn't just a rumor—it was an occupational hazard. Women didn't want to sleep with their bosses, but many felt they had no choice. The pressure was intense and recurrent. I still wonder if my boss asking me on a date was sexual harassment or an innocent act of romantic interest? Given that I felt like my job was at risk if I turned him down, I imagine it wasn't so innocent after all. With the shift to remote work and evolving workplace culture, I hope this kind of harassment is on the decline. Perhaps the next time you hear about women wishing to continue working remotely so they can "care for their children,"

consider that sexual harassment might be among the unspoken reasons.

This chapter is short–not because it's unimportant, but because I'm not here for trauma porn. Dragging out painful experiences to validate what we all know to be true just isn't necessary. We all know the deal: women have faced sexual harassment since forever and have been blamed for it just as long. Sexual harassment and assault have happened since the beginning of time. Whether women were covered head-to-toe in Victorian garb, burqas, or rocking booty shorts, "it's her fault" and "but she was asking for it" narratives have run rampant.

Take Bathsheba, for instance. She gets a bad rap, and no matter how many men try to justify the story and shift blame to her, my eyes are permanently rolling. Before you try to school me on the story of Bathsheba, know this: I've read the Bible cover to cover three times with three different interpretations. I know what I'm talking about. In fact, I could cite countless religious and non-religious texts showcasing instances of sexual harassment, but you probably get the picture. If not, ask the women or trans folks in your life–they'll have plenty of examples for you.

While we're on the topic, you need to know transgender individuals are four times more likely to experience violent crimes like rape or sexual assault compared to cisgender individuals.[37] There is no excuse, no explanation, and no additional tolerance for sexual violence. Men, I call you back into the conversation and urge you to become agents of change, to speak up and speak out if you overhear plans to commit sexual crimes, and most definitely if you witness them in action. It is not our job to be both the victim and savior. Women know what's needed, and we are calling on you to stop this violence.

I strongly suggest that those who are transgender, female, gender fluid, and male (so *everyone*) to report sexual harassment–regardless of the outcome, criticism, ostracism, and consequences. I know it's

scary. Sexual crimes are scary. You deserve to share your truth. Your perpetrator deserves to suffer the consequences of the truth. We are out here ready to support you. We are out here ready to believe you. Find your support system, talk it out, and speak your truth, because you deserve justice and healing.

To the rest of you, believe survivors. Support them. Don't let anyone off the hook when they victim-blame. To anyone questioning victims or wondering if they are lying–full stop. *I will address the women who lie about sexual crimes when you protect the ones who are telling the truth.* Until then, kick rocks and, as a colleague of mine once said, touch grass.

How to be a better human:

1. Believe women who report sex crimes.
2. Do not allow those around you to blame the victim.
3. If you have been the victim of a sexual crime, report it, and know we are here to support you.
4. Find support groups and a good therapist to help you process and heal.
5. Know that you did not deserve this act of violence, and you are not responsible for it, no matter the circumstances. As a community, we are so very sorry for what you have endured.

When Treacherous Paths Cross

With all the craziness happening around us, it can feel like we're stuck in quicksand, losing ground fast. It's easy to feel stressed, anxious, and downright pessimistic. That's why I'm challenging you to carve out your own escape plan. Find that special place where you can recharge and reconnect with your people. It's like Arrested Development sings in "Tennessee": You deserve a place where you can forget your troubles and lay down your burdens, even if just for a bit. This chapter is a rallying cry for those who aren't weighed down to step up, take the load off our shoulders, and fight the good fight so the marginalized can catch our breaths.

Strap in, friends, because this chapter is a bit of a wild ride.

If you're new to the term "intersectionality," welcome to the conversation. Simply put, it's where different identities intersect, typically marginalized ones, leading to heightened discrimination and disadvantage.[38] Picture a Black, Queer individual, or a woman with a disability. Intersectionality means that their uphill climb just got a lot steeper.

Why should you care? Because participants in my study said it means being overlooked, underpaid, and almost invisible in the corporate world. Their inclusion isn't even on the radar in the

C-suite, especially when programs meant to help the marginalized are dominated by the least marginalized among them: white women. Let's throw some stats your way: white women hold 19% of C-suite positions, while women of color, lumped into one big bucket, make up just 4%.[39]

Now is a good time to remind you that two things can be true at once. Women can be marginalized and still marginalize others. Companies boast about high numbers of women in leadership and pat themselves on the back, but a closer look often reveals those women are overwhelmingly white. "Diversity" boxes checked, but the leadership remains a sea of white faces.

For BIPOC folks, hearing about a company's "incredible" diversity numbers only to see a slide full of white women feels like a bait and switch. The landscape remains white, decision-makers are still white, and the power? Yep, still white. So, gender equality might be making strides for white women, but not for all women. This dates back to Affirmative Action, where white women benefited the most, leaving women of color, especially Black women, still struggling.[40] One participant hit the nail on the head with her statement:

"When companies say gender equality what they are usually talking about are white women, not me. A lot of things they talk about, X amount of women at the executive level or we have 50% women...what they really mean are white women."[20]

White women, humor me with this little exercise. Imagine you show up to a women's empowerment event, pumped and ready to go. You look around and see only Black women, not another white woman in sight. You take a seat and look around, noticing the other women looking at you and offering small smiles. How do you feel? Are those smiles comforting or awkward–sympathetic, almost? Does it feel like they're trying too hard? Are you uncomfortable?

Before you fire back with, "No way! I'm not uncomfortable!" just pause for a moment. Close your eyes (but keep a finger on this

page) and really picture it. How many times have you been the "only" one in a room? Probably at least once. But how often has this been your daily reality, for years–for your whole life? That kind of constant isolation–the feeling of being simultaneously invisible and under a microscope–brings a different level of empathy and understanding. This situation becomes especially disturbing when it directly impacts a BIPOC woman's wage.

"I don't make the same money. I don't know why but I am the only Black woman on the team," one woman from my study told me.

This participant was in a whirlwind of "why?" just like when you wonder if a man really meant their comment "that way." It's the self-doubt, the mental gymnastics, the constant questioning that consumes so many of us. We might never know the exact reasons, but we always know that Black women don't get paid the same.

Let's return to the question of why you should care. Science says employee well-being boosts job satisfaction, performance, and retention.[19] Talent won't stick around where they feel unwelcome,[1] and high turnover costs a pretty penny.[15] Most importantly, as humans, we should care about the experiences of our fellow human beings–it all boils down to this crazy little concept called, wait for it, empathy! No apologies for 'shoulding' on you here.

As a white woman or any other type of ally, what can you do to address intersectionality in the corporate world? It's simpler than you might think: just ask questions. Ask questions that "call out" those who exclude and "call in" those who are excluded. Create opportunities for leadership to notice what's missing. Help others be seen, encouraged, and elevated. For instance, consider asking the following questions of yourself and your leadership:

- How many BIPOC employees are on my team? Why aren't there more?
- Which members of my team are marginalized? How often do I elevate them?

- What assignments have I been given, or have I assigned that I could use to spotlight someone from a marginalized community?
- How often do I contribute to the marginalization of another group, either directly or indirectly?
- Have I accepted plum assignments while others repeatedly don't get selected? Do I ask for them to be included? Do I proactively include them?
- How often do I create situations that elevate the visibility of those who are marginalized?

This isn't charity. This is what prevents airbags from killing women because only male test dummies are used.[41] This is what ensures AI facial recognition doesn't get innocent BIPOC people arrested.[42] Without a truly diverse (sex, gender, religion, sexual orientation, and the like) representation in the room, companies make costly mistakes.

At your next team meeting, shake things up. Create space for those who aren't usually heard. Change the dynamic by modeling true inclusivity. Let it reverberate through the team. Help those struggling to see over a six-foot fence when they're four feet tall. Giving them a ladder isn't charity; it's a necessity. Once everyone can see over the fence, you'll get a richer perspective. One person might see a field of grass, another might see every single blade, and someone else might notice clouds on the horizon and suggest building a shelter. That's the power of diversity. That's why intersectionality matters. That's why companies must care. And if that's not enough, remember: a diverse workforce boosts profits by 15-35%.[10] No matter how you slice it, true intersectional diversity is crucial.

Ask the tough questions so those who are marginalized are seen, elevated, and engaged. If you feel like someone from a marginalized group is taking your spotlight, remember that the spotlight was

never just yours. It belongs to the collective until claimed. You're just making space for everyone to run the same race.

Time for some *very* deep reflection:

1. Think about when you may have marginalized someone.
2. Ask why there isn't more inclusion on your team.
3. Speak up when you see people being pushed aside.
4. Elevate those from marginalized communities; include them in your projects and request them by name.
5. Do better.

The Power of Allyship:
Why (White) Men Need to Step Up

Start speaking up; your history of silence has not done us any good. What we really need is to hear you be brave. If you are wondering how intensely I mean this, listen to Sara Bareilles and the words of her song, "Brave." We need your words to be anything but empty, we need your support, and we deserve your allyship.

Hey there, (white) men! Thank you for being part of the conversation. You've made it through the book, which shows your commitment to change, or at least your commitment to understanding.

It might surprise you to learn that I have a pretty traditional home. I do the majority of the cooking and meal planning (thank you, meal kits) and grocery shopping (thank you, Instacart). I pack lunches every day with a kind note, do the laundry, and care for my mother (yes, mom, I am more than happy to take you to the gym). For all these reasons, I'm not responsible for yard maintenance; pest control; service complaints of any kind; home maintenance; car refueling, cleaning, and maintenance; opening doors; picking up prescriptions; or running out for late-night snacks.

The real power within my household is how we flex the division of chores. If I'm tired after a challenging day at work, my husband

proactively offers to pick up food. If he's exhausted after a particularly grueling day, I'll grab the package at the front door. Partnership is the foundation of our relationship.

It's important for you to know I don't consider men (including white men) the enemy. I don't want to damage your relationships; I want to overhaul the choices available to you and your partner. I want to disrupt your thinking and radicalize your advocacy.

As I mentioned earlier, some of you have already been incredible mentors, advocates, and partners for women. Please don't take this section being stuck at the end of the book to be an indication of importance. *While this section is separate it is still equal.*

Now, let's dive deep into a crucial topic: why it's absolutely essential for you to step up and be a steadfast ally for the BIPOC (Black, Indigenous, and People of Color) community and women in the workplace–and beyond. Stay tuned and take notes as you read the breakdown of how you can make a difference.

Getting Real About Allyship: What It Means and Why It Matters

Allyship isn't just about wearing a Black Lives Matter pin or retweeting feminist slogans. It's about actively using your privilege to dismantle the barriers that BIPOC individuals and women face every day. It's about listening, learning, and then doing something about the inequality and inequity that's been ingrained in our systems for way too long.

Why White Men? Because Your Privilege is a Superpower

Let's face it, guys–you've got some serious advantages just by virtue of being white, cisgender, and male in a world that often values those traits above all else. But instead of coasting on that privilege,

how about flipping the script? Use it to open doors for others who might not have the same opportunities.

Intersectionality 101: BIPOC Women and Double the Struggle

1. Addressing Structural Inequities:

BIPOC women? We've got it rough. We're dealing with racism and sexism at the same time. As an ally, you can't just pick and choose which battles to fight. You have to be in it for the whole shebang–pushing for fair policies, smashing bias in hiring and promotions, and making sure BIPOC women's voices are front and center where decisions get made. Time to flex that privilege for good!

2. Supporting Career Advancement:

BIPOC and women hit roadblocks left, right, and center when it comes to climbing that career ladder (think biases, stereotypes, and not getting the same access to resources). White men, you have the power to change this game. Step up with mentorship, sponsorship, and boosting our professional growth. We're talking about paving paths to the top and making sure every floor has a diverse crowd.

3. Creating Inclusive Work Cultures:

Picture this: workplaces where everyone feels like they belong. White, cisgender men, you're crucial in making that happen. Call out racist and sexist behavior or language and fight tooth and nail for policies that embrace all backgrounds. Create safe spaces where women and BIPOC individuals know their worth and can bring our A-game without looking over our shoulders. Trust me, watching your back day in and day out is *exhausting*.

Challenges and Opportunities in Allyship

1. Navigating Resistance:

When it comes to DEI (Diversity, Equity, and Inclusion), some people panic, worried it will be the end of their comfy status quo. As a white, heterosexual man stepping up as an ally, you may face skepticism and pushback from those clinging to the old ways. Overcoming this mess takes courage, persistence, and a truckload of education. Time to school the naysayers and push for fairness like *your* job depends on it.

2. Education and Self-Reflection:

So, you want to be a top-notch ally? It's not just about carrying the flag; it's about putting in the work. Announcement for all cisgender, white men: you have to keep learning. Dive into books, workshops, and spend time with people who challenge your worldview. Get cozy with literature by women and the BIPOC community—lean into learning. Embrace self-reflection as your own personal reality check on race, gender, privilege, and power. Time to dismantle those old inequities and build a new, inclusive world, one workshop at a time.

How to Be a Rockstar Ally: Tips and Tricks

1. Educate Yourself:

Alright, first things first: put those listening ears on and tell your ego to take a backseat. It's not about you right now. Really, truly listen. Seek to understand the experiences and challenges faced by women and the BIPOC community without making it about yourself. Read up on systemic racism, sexism, and the ways privilege plays out in everyday life. Educate yourself so you can speak up with knowledge and empathy.

2. Amplify and Advocate:

Don't just sit on the sidelines. Use your voice and influence to advocate for change. Amplify the voices of women and the BIPOC community during meetings, shout out our ideas, and challenge biased assumptions when you see them. Show up for diversity initiatives, and don't let anyone dismiss them as "not a big deal." Start by not scheduling company meetings during DEI events. That way everyone can attend. Speak up when you notice that DEI events have been overbooked so we don't have to be "that guy."

3. Speak Up and Show Up:

Don't turn a blind eye when you see discrimination going down, whether it's a microaggression (see the definitions section of this book) or a blatant act of bias. Step in. Show support, call out the offenders, and school them on why their behavior is offensive. Build a culture where respect and inclusivity aren't just buzzwords, but the real deal. Ask yourself (and your company's leadership) why there's only one BIPOC person on the decision-making team, or any team for that matter.

4. Champion Formalized DEI Leadership

Ask why the person responsible for leading DEI at the company is a *white* woman or white man (or a Brown person for that matter) with no formal training or credentials. Treat this effort with the same importance you place on the VP of Sales or Marketing. Be aware and call out when DEI is positioned within an organization that puts it at odds with true DEI success. For example, if your DEI team is housed under the human resources department, and HR has been mandated to improve employee culture, reporting that DEI is lacking is at odds with HR's (and company leadership's) objective. This can cause underreporting (and sometimes no reporting at all)

in key areas like company demographics, equity complaints, and BIPOC employee concerns.

Also, make sure the role is properly leveled. For example, why is there only a director-level DEI leader at your company? Why doesn't the individual responsible for DEI at your company hold a VP title and report directly to the CEO? This is a surefire way to ensure messaging from marginalized employee groups isn't filtered.

These difficult tasks fall squarely on you, white men, because you are more likely to be in a high-level position that can implement change. If you consider yourself a true ally, then it's time to speak up. Remember, you can't have the wolf guarding the hen house.

5. Be a Problem-Solver:

Time to do some soul-searching. Reflect on your privilege, check those biases at the door, and keep learning. This isn't a one-time deal–it's a journey. Resist the temptation to make the marginalized do unpaid or "volunteer" work to improve your company's work culture–that's just free labor. Marginalized people are already paid less, so don't ask them to do additional, uncompensated work to correct the injustices committed against them. That means those "employee resource groups" dedicated to marginalized groups shouldn't be doing the heavy lifting. They aren't' the ones who should bear the responsibility for driving solutions and creating change. As a true ally, connect with other allies and do the work amongst yourselves, then gut check with your employee resource groups so everyone feels seen and valued (and compensate them for that gut-check). Ensure your understanding and solutions are aligned in a way that does not take advantage of the barely existent marginalized communities within your organization. Develop solutions that are impactful and not just feel-good projects. Let's grow together and kick systemic inequities to the curb!

Celebrating the Wins

Let's hear it for the men who've stepped up and made a difference! From advocating for inclusive hiring practices to mentoring marginalized colleagues and standing up against workplace discrimination–these are the stories that inspire us to keep pushing forward. These allies aren't just talking the talk; they're walking the walk and making workplaces better for everyone.

Let's Make Change Happen

Remember this: allyship is a journey, not a destination. Keep learning, keep growing, and keep showing up. Together, we can build a world where diversity isn't just celebrated–it's the norm. So, here's to the incredible allies breaking down barriers and creating a future that's brighter and more inclusive for all.

Loud Whispers

I have never liked the phrase, "What doesn't kill you makes you stronger." It is a way to excuse the abuser and glorify the offender. Women are more than strong enough; no additional trials are required or requested. However, there is a particular strength when Kelly Clarkson sings it in her song "Stronger." I hope to leave you with just a bit more strength (and tools) as you continue your journey.

As we close out this journey through what many of us know to be true and what some of us are just realizing, remember that there's plenty of light in this tunnel, and even more at the end of it. Accomplishments, allyship, and perseverance shine bright, proof that a book like this can even hit the shelves. There's an audacious hope in every woman, BIPOC, and Queer individual who gets up each day and conquers the corporate jungle. Those whispers of injustice are getting louder by the month. A fierce energy is rising, forcing change and seizing opportunities to make a real impact.

The most crucial change is giving yourself the green light to support your own best efforts. Allocate resources to fuel your excellence. Transform those little pockets of non-support into vast swaths of undeniable productivity.

You have every right to ditch what doesn't serve you–daily, monthly, yearly. Science backs up your experiences and validates your right to set boundaries that help you thrive. You deserve a supportive partner in your corner (human or otherwise). Now you know what to do, what to pursue, and what to avoid.

Be uncompromising in your expression of self-care. Be loud and proud in rejecting bias and the destruction it causes for incredible female leaders. Be proactive with your questions when you step into those monolithic spaces. Be the fullest expression of your talents, abilities, curiosity, and self. I'm here, standing in support of *you*.

So, next time someone tells you to fix your face or suggests you watch your tone, just tell them you don't have to–Dr. V said so!

About The Author

Going back to school after 40 is not for the faint of heart, and the journey from prison to published researcher is even more challenging. Nevertheless, Dr. V returned to school in 2017, obtaining her BS in Marketing Management, MS in Management and Leadership, Master of Business Administration, and Doctor of Business Administration in Organizational Leadership.

Some might see four degrees as excessive, but life as a Black woman with a felony has proven otherwise. Going from just a speeding ticket to having a felony was painful to face as a single mother with two small children, and 20 years ago, finding employment with that background seemed impossible. Any source of income was welcome, and Dr. V did everything from stripping to picking up dog poop with just a grocery bag around her hand to make ends meet.

Inspired by her personal, professional, and educational experiences, Dr. V is now an established keynote speaker and leader in the organizational leadership and equity space. Her groundbreaking research bridged the gap between work-life balance and social support. Dr. V uses her published research to disrupt and redefine training and enablement programs, resulting in improved performance and increased revenue. Her mission is to rewrite the narrative for marginalized groups in the workplace through innovative and accessible programming, enlightening one unaware mind at a time.

References

1. Brue, K. L. (2019). Work-Life balance for women in STEM leadership. *Journal of Leadership Education, 18*(2). https://doi.org/10.12806/v18/i2/r3

2. Brue, 2019; McCullough, L. (2019). Proportions of women in STEM leadership in the academy in the USA. *Education Sciences, 10*(1), 1–13.

3. Yang, Y., & Carroll, D. W. (2018). Gendered microaggressions in science, technology, engineering, and mathematics. *Leadership and Research in Education, 4*, 28–45

4. Blazina, C. (2024, April 14). What's behind the growing gap between men and women in college completion? *Pew Research Center*. https://www.pewresearch.org/short-reads/2021/11/08/whats-behind-the-growing-gap-between-men-and-women-in-college-completion/

5. Chau, V. S., & Quire, C. (2020). Back to the future of women in technology: insights from understanding the shortage of women in innovation sectors for managing corporate foresight. In *Routledge eBooks* (pp. 123–140). https://doi.org/10.4324/9780429318559-10; Cidre, D. V. (2021). The challenges of integrating women in leadership positions in

the Technology Industry. *International Journal of Innovation Management, 15*(4), 619–653.v; Gipson, A. N., Pfaff, D. L., Mendelsohn, D. B., Catenacci, L. T., & Burke, W. (2017). Women and leadership. *The Journal of Applied Behavioral Science, 53*(1), 32–65. https://doi.org/10.1177/0021886316687247

6. White, S. (2021). Women in tech statistics: The hard truths of an uphill battle. *CIO.* https://www.cio.com/article/201905/women-in-tech-statistics-the-hard-truths-of-an-uphill-battle.html

7. McCullough, L. (2019). Proportions of women in STEM leadership in the academy in the USA. *Education Sciences, 10*(1), 1–13.

8. Ashcraft, C., McLain, B., & Eger, E. (2016). *Women in tech: The facts.* https://wpassets.ncwit.org/wp-content/uploads/2021/05/13193304/ncwit_women-in-it_2016-full-report_final-web06012016.pdf

9. Hubbert, J. (2023, November 14). 70+ women in Technology Statistics (2024). *Exploding Topics.* https://explodingtopics.com/blog/women-in-tech; McCullough, 2019

10. Prince, S., Hunt, D. V., Dixon-Fyle, S., & Dolan, K. (2020). Diversity Wins: How Inclusion Matters. *McKinsey & Company.* https://www.mckinsey.com/featured-insights/diversity-and-inclusion/diversity-wins-how-inclusion-matters

11. Hunt, S. H. (2018). Embodying self-determination: beyond the gender binary. *Determinants of Indigenous Peoples' Health.*; Boykin, V. (2023). The Role of Social Support in Achieving Workplace Equity-Women Know What's Needed (Doctoral dissertation, Northcentral University).

12. Hupfer, S., Mazumder, S., Bucaille, A., & Crossan, G. (2022). Women in the tech industry: Gaining ground, but facing new headwinds. *Deloitte Insights.* https://www2.deloitte.

com/xe/en/insights/industry/technology/technology-media-and-telecom-predictions/2022/statistics-show-women-in-technology-are-facing-new-headwinds.html

13. Brue, K. L. (2019). Work-life balance for women in STEM leadership. *Journal of Leadership Education, 18*(2), 1–9; Gokhroo, N., & Sharma, B. S. (2019). Work-life balance of employees: Theoretical conceptual framework. International Journal of Education, Modern Management, Applied Science & Social Science, 1(2), 118–128.

14. Annabi, H., & Lebovitz, S. (2018). Improving the retention of women in the IT workforce: An investigation of gender diversity interventions in the USA. Information Systems Journal, 28(6), 1049–1081.

15. Wigert, S. M. and B., & McFeely, S. (2024, April 5). This fixable problem costs U.S. businesses $1 trillion. Gallup.com. https://www.gallup.com/workplace/247391/fixable-problem-costs-businesses-trillion.aspx

16. Mcfeely, S. and Wigert, B. (2019) This Fixable Problem Costs U.S. Businesses $1 Trillion, Gallup.com. Available at: https://www.gallup.com/workplace/247391/fixable-problem-costs-businesses-trillion.aspx#:~:text=The%20cost%20of%20replacing%20an,to%20%242.6%20million%20per%20year.

17. Weisul, K. (2011, March 25). *Why mentoring helps men more than women.* CBS News. https://www.cbsnews.com/news/why-mentoring-helps-men-more-than-women/

18. Prince, S., Hunt, V., & Dixon-Fyle, S. (2020, May 19). *Diversity wins: How inclusion matters.* mckinsey.com. Retrieved July 15, 2022, from https://www.mckinsey.com/featured-insights/diversity-and-inclusion/diversity-wins-how-inclusion-matters; Boykin, V. (2023). *The Role of Social Support in Achieving*

Workplace Equity-Women Know What's Needed (Doctoral dissertation, Northcentral University).

19. Duan, X., Ni, X., Shi, L., Zhang, L., Ye, Y., Mu, H., Li, Z., Liu, X., Fan, L., & Wang, Y. (2019). The impact of workplace violence on job satisfaction, job burnout, and turnover intention: The mediating role of social support. *Health and Quality of Life Outcomes, 17*(1), 1–10; Freak-Poli, R., Ryan, J., Tran, T., Owen, A., McHugh Power, J., Berk, M., Stocks, N., Gonzalez-Chica, D., Lowthian, J. A., Fisher, J., & Byles, J. (2021). Social isolation, social support and loneliness as independent concepts, and their relationship with health-related quality of life among older women. *Aging & Mental Health, 26*(7), 1335–1344. https://doi.org/10.1080/1360786 3.2021.1940097

20. Boykin, V. (2023). *The Role of Social Support in Achieving Workplace Equity-Women Know What's Needed* (Doctoral dissertation, Northcentral University).

21. Saxena, M., Geiselman, T. A., & Zhang, S. (2019). Workplace incivility against women in STEM: Insights and best practices. *Business Horizons, 62*(5), 589–594.

22. Alqahtani, T. H. (2020). Work-life balance of women employees. *Granite Journal, 4*, 37–42; Brue, K. L. (2019). Work-life balance for women in STEM leadership. *Journal of Leadership Education, 18*(2), 1–9; Duan, X., Ni, X., Shi, L., Zhang, L., Ye, Y., Mu, H., Li, Z., Liu, X., Fan, L., & Wang, Y. (2019). The impact of workplace violence on job satisfaction, job burnout, and turnover intention: The mediating role of social support. *Health and Quality of Life Outcomes, 17*(1), 1–10; Singh, A. (2021). An Introduction to experimental and exploratory research. *SSRN Online Journal*, 1–7. https:// doi.org/10.2139/ssrn.3789360; Sharma, A. (2019). *Factors*

influencing women to choose careers in technology despite the underrepresentation of women in the field [Doctoral dissertation, Northcentral University]. ProQuest Dissertations and Theses Global.

23. Prince, S., Hunt, V., & Dixon-Fyle, S. (2020, May 19). *Diversity wins: How inclusion matters.* mckinsey.com. Retrieved July 15, 2022, from https://www.mckinsey.com/featured-insights/diversity-and-inclusion/diversity-wins-how-inclusion-matters; Shin, D., & Enoh, J. (2020). Availability and use of work–life balance programs: Relationship with organizational profitability. *Sustainability, 12*(7), 2965.

24. Khan, S., & Agha, S. (2018). Exploring gender differences in level of happiness among university students. *Balochistan Review, XXXIX*(2), 287–293; Boykin, V. (2023). *The Role of Social Support in Achieving Workplace Equity-Women Know What's Needed* (Doctoral dissertation, Northcentral University).

25. Folke, O., & Rickne, J. (2020). All the single ladies: Job promotions and the durability of marriage. *American Economic Journal: Applied Economics, 12*(1), 260-287.

26. Kumar, K. (2021, June 10). *How long does it take to recover from delivery? (Postpartum recovery).* MedicineNet. https://www.medicinenet.com/how_long_does_it_take_to_recover_from_delivery/article.html

27. Cech, E. A., & Blair-Loy, M. (2019). The changing career trajectories of new parents in STEM. *Proceedings of the National Academy of Sciences, 116*(10), 4182–4187.

28. Sowjanya, K., Krishna, S., & Rao, I. N. (2017). Impact of gender discrimination on talent management. *International Journal of Engineering Technology Science and Research, 4*(11), 1172–1178.

29. Financial Mistakes Women Make During The Divorce Process | Northern Trust. (n.d.). *Northern Trust.* https://www.northerntrust.com/united-states/institute/articles/financial-mistakes-women-make-during-the-divorce-process#:~:text=to%20avoid%20them.-,On%20average%20a%20woman%20can%20expect%20an%20almost%2030%2-5%20decline,an%20increase%20of%2010%25.%22

30. Howington, J. (2024, April 5). The New Nomads: Insights from FlexJobs' 2024 Work-From-Anywhere survey. *FlexJobs Job Search Tips and Blog.* https://www.flexjobs.com/blog/post/flexjobs-work-from-anywhere-survey/

31. *BIPOC renters hit hardest by high rent costs - Apr 29, 2024.* (2024, April 29). Zillow MediaRoom. https://zillow.mediaroom.com/2024-04-29-BIPOC-renters-hit-hardest-by-high-rent-costs#:~:text=In%202022%2C%20the%20typical%20BIPOC,to%2032%25%20for%20white%20households

32. Blazina, C. (2024b, April 14). What's behind the growing gap between men and women in college completion? *Pew Research Center.* https://www.pewresearch.org/short-reads/2021/11/08/whats-behind-the-growing-gap-between-men-and-women-in-college-completion/

33. Madsen, S. R., & Andrade, M. S. (2018). Unconscious Gender Bias: Implications for Women's Leadership development. *Journal of Leadership Studies, 12*(1), 62–67. https://doi.org/10.1002/jls.21566

34. Comaford, C. (2021, June 26). What people really think about females in leadership [Infographics]. *Forbes.* https://www.forbes.com/sites/christinecomaford/2021/06/26/what-people-really-think-about-females-in-leadership-infographics/?sh=60f775716606

35. Kubiak, E. (2023, July 9). Psychology Today. https://www.psychologytoday.com/us/blog/the-behavioral-science-hub/202307/women-as-leaders-our-brains-may-be-wired-to-say-no#:~:text=The%20reality%20remains%20that%20women,a%20significant%20gender%20promotion%20gap.

36. Dunn, C. E., Hood, K. B., & Owens, B. D. (2019). Loving myself through thick and thin: Appearance contingent self-worth, gendered racial microaggressions and African American women's body appreciation. *Body Image, 30*, 121–126. https://doi.org/10.1016/j.bodyim.2019.06.003

37. The Williams Institute at UCLA School of Law. (2022, December 21). *Transgender people over four times more likely than cisgender people to be victims of violent crime - Williams Institute*. Williams Institute. https://williamsinstitute.law.ucla.edu/press/ncvs-trans-press-release/

38. Hankivsky, Olena. *Intersectionality 101. womensstudies.colostate.edu*, https://womensstudies.colostate.edu/wp-content/uploads/sites/66/2021/06/Intersectionality-101.pdf.

39. Tulshyan, R. (2019, July 2). *Do your diversity efforts reflect the experiences of women of color?* Harvard Business Review. https://hbr.org/2019/07/do-your-diversity-efforts-reflect-the-experiences-of-women-of-color

40. Reid, M. (2020, February 21). What happens when white women become the face of diversity. *Forbes*. https://www.forbes.com/sites/maryannreid/2020/02/18/what-happens-when-white-women-become-the-face-of-diversity/?sh=20e06f55287d

41. Epker, E. (2023, September 12). Fasten your seatbelts: A female car crash test dummy represents average women for the first time in 60+ years. *Forbes*. https://www.forbes.com/sites/evaepker/2023/09/12/fasten-your-seatbelts-a-female-car-

crash-test-dummy-represents-average-women-for-the-first-time-in-60-years/?sh=1634d5e555ba

42. Najibi, A. (2020, October 26). *Racial discrimination in face recognition technology - Science in the news.* Science in the News. https://sitn.hms.harvard.edu/flash/2020/racial-discrimination-in-face-recognition-technology/

Review Requested:

We'd like to know if you enjoyed the book.
Please consider leaving a review on the platform
from which you purchased the book.

Printed in the USA
CPSIA information can be obtained
at www.ICGtesting.com
LVHW041043200824
788522LV00004B/18